Large-scale Ceram

W9-ADZ-255

LARGE-SCALE CERAMICS

Jim Robison

A&C Black • London

American Ceramic Society • Ohio

To my wife, Liz (a self-proclaimed potter's moll),
and our children, David, Amy and Lloyd

First published in Great Britain in 1997
A & C Black Publishers Limited
Alderman House, 37 Soho Square
London W1D 3QZ
www.acblack.com

Reprinted 2005

ISBN-10: 0-7136-7462-8
ISBN-13: 978-0-7136-7462-0

Published simultaneously in the USA by
American Ceramic Society
735 Ceramic Place
Westerville, Ohio 43081

ISBN 1-57498-264-8

Book design by Alan Hamp and Susan McIntyre.
Cover design by Sutchinda Rangsi Thompson.

COVER (FRONT): Twin Town commemorative sculpture (Cambridge and
Heidelberg) by Jim Robison.
COVER (BACK): *Bid Ben Bid Bont*, by Gwen Heeney, situated at Llanfyllin,
Wales.

Printed and bound in China by WKT.

Contents

Acknowledgements

The first task is to thank all of those who have helped in the preparation of this book. It includes my Editor, Linda Lambert, Simon Morley for his excellent photography, Tony Mosley who was my able assistant during several of the projects illustrated, Diane Scott for help on many fronts, including the task of proof reading, contributing potters, others who have shared their experience and inspired me, friends, enthusiasts and my family, who have given support to ideas and efforts over the years. argument, and for thought-provoking stimulation, I would like to remember Mr Les Wight, now sadly deceased, the college art teacher whose encouragement and introduction to the likes of Peter Voulkos, Daniel Rhodes and Paul Soldner, started me down this road.

For those who choose to follow the path of artist/potter, there is now a worldwide network of people and publications to draw upon and this book is in part the result of my good fortune in being able to take part in events and activities at various places on the globe. I sometimes think potters are unique in their willingness to share information. And they do not stop there, for they regularly use up vast amounts of energy in the organisation of international events to better distribute their enthusiasms. It would be an impossible task to list all of the individuals and potters' organisations who have contributed to my thinking and directly or indirectly to this book. The North and South Wales Potters, Northern Potters and Craft Potters Associations of Great Britain have all helped to generate a truly international outlook on ceramics in the UK, and for the chance to be associated with so many members of these groups, I am very grateful. I would also like to thank Tsipi Itai and Magdalena Hefetz for the invitation to participate in the Israeli Ceramics Biennale in Beer-Sheva, and Janet Mansfield for Clay-Sculp Gulgong in Australia.

Introduction

A book about Large-Scale Ceramics has been on my mind for a number of years. As a collection of ideas, it could serve as a stimulus to others sharing the enthusiasms of potters and sculptors who have captured my imagination from many parts of the globe. As a collection of technical notes, it should help those whose imagination runs ahead of their know-how and offer some guidelines as to how things might be done.

It is with affection that I recall reading *Environmental Ceramics* by Stan Bitters. It provided me with an exciting stimulus to work large, to not be intimidated by the challenge of scale and to revel in the manipulation of vast quantities of clay. For as a friend reminded me on hearing about this book, 'It is like tossing a pebble into a pond. The ripples extend far beyond the event.' I hope this volume will have a similar effect on others.

Definition

When contemplating large scale, there are numerous approaches one might take. One could simply use a particular definition of size, with all items reaching a specific height to be included. *The Concise Oxford Dictionary* defines *large* as being of *considerable magnitude* and includes *as large as or larger than life*. Using this definition, the amount of clay involved, the area covered or sheer weight of the object could be the important factors. One approach would be to study a group or classification of pottery, say vases or jugs for example, and then pick out particularly big examples of such work. Yet another possibility is to consider the degree of difficulty in any given work; the extremes to which creative individuals will go to in the quest for outstanding achievement. In this case, one might look at the scale of the maker's *concept*, the ambition represented by the piece of work. An impressiveness in sculptures and relief panels does not have an 'expected' size except as they relate to a given site or location. All of these approaches have a certain validity and I will attempt to explore some of the aesthetic and technical difficulties encountered in such work.

My own fascination with large scale probably stems from making sculptures in other materials and the experience of creating works intended for Michigan gardens (those occasionally vast spaces known as front or back *yards*). Using wood or metal structures, it was relatively easy to create sculptures on a scale to dwarf the onlooker. Under such circumstances I think it has always been important to me that pieces should be large enough to be noticed, even at a distance, and it was even better if they could command attention through a physical presence which could not be ignored. Perhaps, also, it was the result of growing up in America in the 1960s on a diet of Peter Voulkos, Paul Soldner and Daniel Rhodes that led me to accept the idea of larger pieces of ceramic as normal fare.

When a move from Michigan to

Yorkshire prompted a rethink about the work I was doing, an ongoing involvement with clay became the deliberate focus of attention. Steel and wood were expensive and required specialised equipment which I had left behind. Clay, on the other hand, was relatively cheap and a kiln could be built with modest means. Beginning in a small way, I found the makings of a studio in an old coaching stable in Leeds and began to produce thrown and handbuilt items for a new public.

Large coiled pots by Monica Young, on show at the author's Booth House Gallery, Holmfirth, W. Yorkshire. *Photograph by Maurice Elstub.*

What I did not leave behind was an enthusiasm for larger works. The desire to be confronted by imagery remained and the scale of work began to grow. In 1980, my wife and I organised a 'Big Pots' exhibition at our studio/gallery. I was impressed with the similarity between Monica Young's (UK) huge pots and the feeling one gets in museum settings – classic forms and timeless beauty. Mick Casson (UK) arrived with his large salt-glazed jugs and his jaw dropped on seeing the scale of Monica's work. Recovering quickly, he said, 'we will just have to call these *cream jugs*'. It just underlines the importance of our definitions.

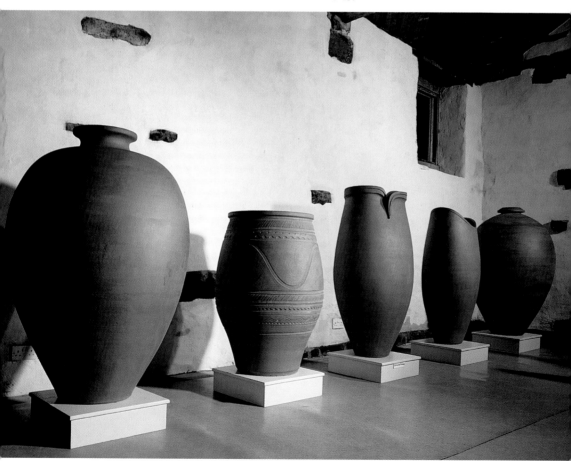

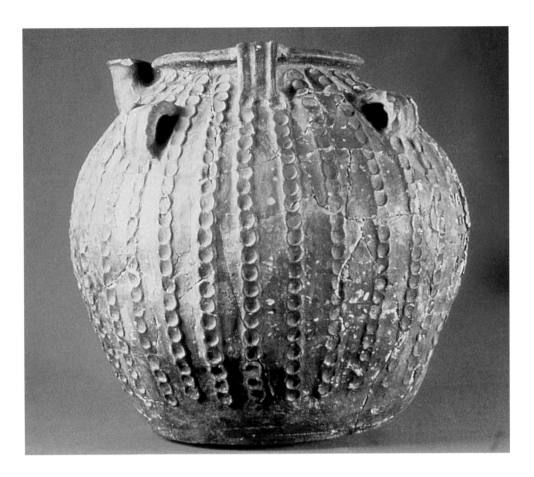

Torksey ware, 10th century liquid storage vessel. This original was used by the author to create replicas for the Jorvik Viking Centre, York. *Photograph courtesy of the York Archaeological Trust.*

Soon after the 'Big Pots' show, an invitation to display my ceramic work in the open air of the Yorkshire Sculpture Park provided a catalytic stimulus. This show featured Tony Hepburn and included many large sculptures. The excitement of seeing so many ideas expressed on such a dynamic scale helped to reaffirm my view of ceramics as an important part of the dynamic Fine Art world.

All of this is just to say that *large* is partly what you get used to and partly what you enjoy. My own view is that to work large is to accept a challenge – that arm movements are easier for me than those at the finger end, and that pieces which reach out to meet the viewer – on his own terms of scale – create an interaction or dialogue – much more difficult to achieve in small works. To have to walk around a piece makes it difficult to ignore. It does require a certain amount of optimism and willingness to take risks. It requires a certain commitment and energy to be applied over an extended period of time. It also requires the ability to bounce back from frustrations and the occasional disaster.

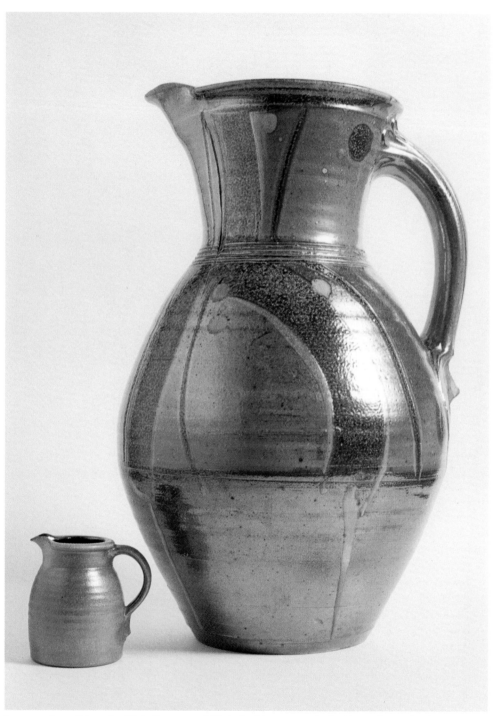

Large and small jugs by Mick Casson and Chris Jenkins respectively. From the author's collection. *Photograph by Simon Morley.*

Chapter One
General making methods

All the traditional ceramic making methods are applicable to work done on a larger scale – it only requires an ability to think BIG and a bit of ingenuity. Below I will describe how some well-known artists have used and adapted various methods to produce some outstanding work.

Coil and pinch

Manipulations of the clay between the fingers and hands must be the oldest and arguably the most sensitive form of making. Building is so direct and feedback from the fingers conveys instantaneous information about moisture content, thickness, form and surface.

Gudrun Klix (Australia) illustrates the advantages of coil building in this spiral piece she built over a period of a few days at Clay Sculpt in Gulgong, Australia in the summer of 1995. Where slabs often retain a sense of rigidity and limit the movement of the clay to one direction only (as when bending paper), coils can be manipulated in any direction which permits greater freedom of form. However, it is necessary to know where you are going with the work, because as you are always building from the base up, trying to imagine the top of the form early on is not easy. A scale model can be

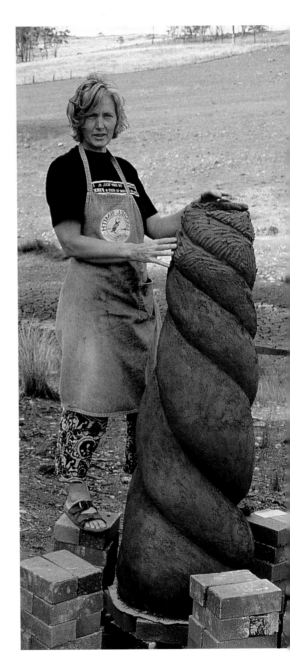

Coil-built sculpture by Gudrun Klix (Australia) being made at Gulgong, Australia.

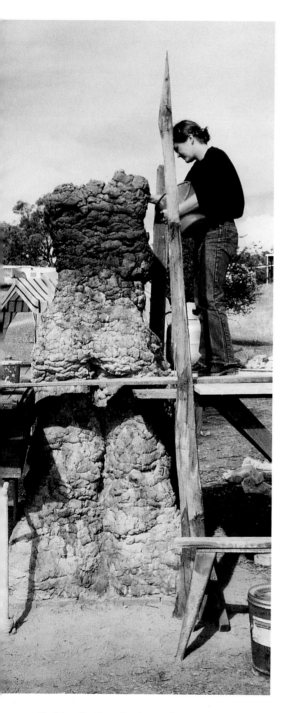

of considerable help in visualising the work in progress.

In 'Homage to Wisdom' Tova Beck-Friedman (USA) has created very large works through an extension of the coiling method. She tears small pieces of clay, and pinches them together, smoothing only on the inside of the piece. To hasten the process, she uses a torch, blowing only on the outside. This allows the piece to retain moisture on the interior of the sculpture, permitting new clay to adhere, while accentuating the outer texture. The varied shapes and sizes create an attractive natural surface.

Colour is achieved with metallic oxides that are rubbed into the surface in its leatherhard stage. When the piece is bone dry, she rubs the raised areas with steel wool, pushing oxides into the crevices.

In her 'Homage to Wisdom' group, each figure is made in three sections – each section made to fit the height of the kiln. A ledge is made at the top of each part to accept the section that will rest on top of it. The work is fired once to 1280°C (2330°F). The clay used is rough and open, consisting of

40% Fireclay
10% Rough grog
15% Medium grog
35% Ball clay

Carol Windham (UK) builds her figures from a more refined coil building method. Coiled forms are scraped down and surfaces worked into. As put by Emmanuel Cooper in his review of her work in a London show, 'these look as if they have been honed down rather than built up'. These pieces are nearly life size. She starts with extensive drawing and attempts to combine an interest in the traditional pot form with visions of the female figure. In 'The Tea Drinker', she started with the central stem of the body,

Goddess by Tova Beck-Friedman, being made at Gulgong, Australia. Copper oxide wash is being applied before firing on site.

Coiled figure in the making by Carol
Windham (UK)

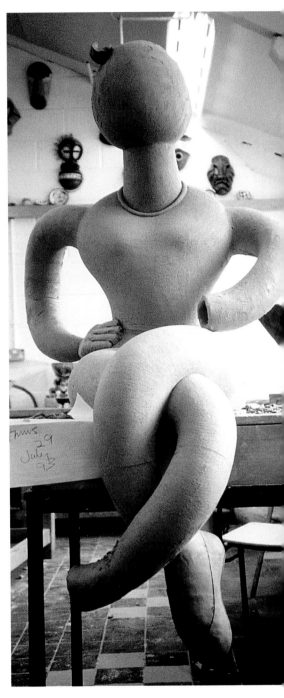

but then, rather unusually, had to coil
downwards for the limbs.

Her refinement is also evident in the
clay she chooses to use – industrially-
manufactured 'T' material – which is
incredibly strong (and equally expensive).
Another example of this refinement can
be seen in the detail which is drawn into
the surface and picked out with oxides.

Carol worked for a time as an assistant
in the studio of the American sculptor,
Robert Arneson. The expressive, larger
than life portraits for which he is known
also demonstrate extraordinary skills and
great sensitivity to materials. These
combine a number of methods, being
built up and modelled on a thrown base.
Moulds are also used to define features of
the head.

Coiled figure in process by Carol Windham. 'T'
material is used. Unusually, arms and legs are
being coiled downwards.

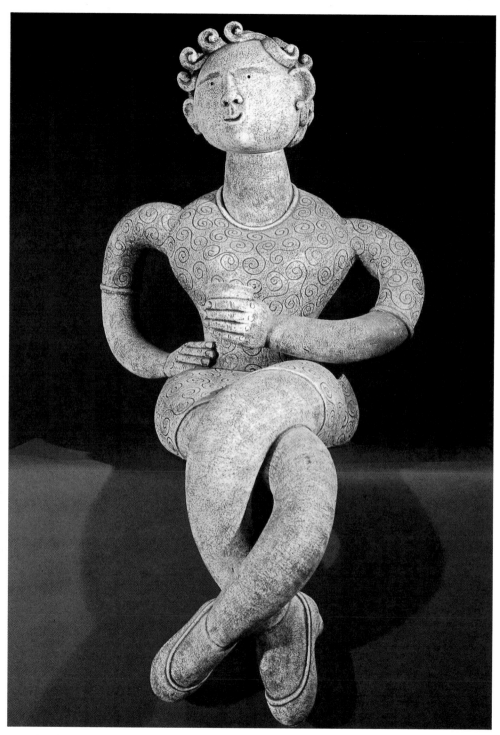

Completed figure entitled 'Tea Drinker' by Carol Windham. It is approximately ⅞ life size.

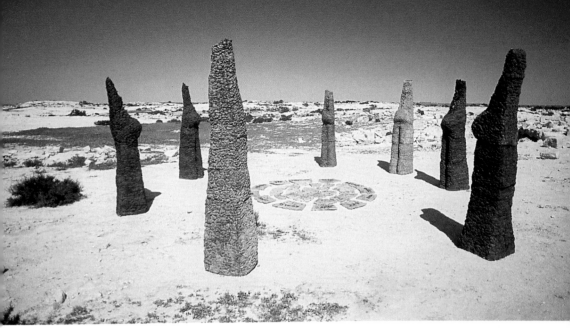

'Homage to Wisdom', by Tova Beck-Friedman (USA), 7 foot (175 cm) high. *Courtesy of the Herzliya Museum, Israel.*

Right
'Chemo 1' in studio by Robert Arneson, approximately 4 foot (120 cm) high. *Photograph by Carol Windham.*

Use of the wheel

Coil and throw

The initial use of a revolving disc or support for clay was closely related to coil building i.e. forming and smoothing manageable amounts of clay onto the rim of the pot below. This still is one of the easiest methods of creating large forms on the wheel. The base, or initial starting point can be centred and then allowed to harden enough to support additional weight. Use sufficient clay to make a base of a thickness appropriate to the scale of the intended work.

The rim must be kept moist (cover in plastic) until lower sections are firm and then be well-scored and slipped to insure secure jointing of additional coils to the

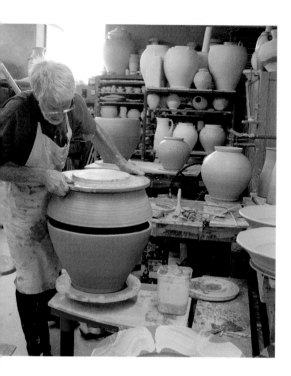

near the base, a more uniform thickness may be easier achieve when pieces are placed rim to rim. The top section can be thinned by additional throwing and the lower section trimmed as desired.

David Frith (UK) makes enormous jugs in three sections. The first two are cylinders stretched into deep bowls, which are attached rim to rim. The third is a short cylinder which provides generous amounts of clay for a substantial rim and spout. This seems to be a better solution than the struggle to

Left
Two bowls are joined together at the rims to create a larger pot. The throwing bat is cut free after positioning inverted bowl.

Below
Throwing the rim of the large pot.

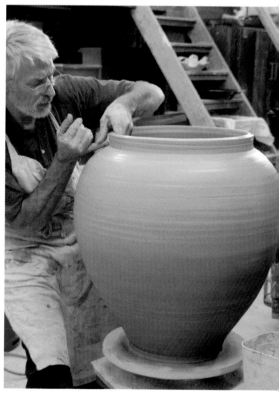

pot below. If in a hurry, gas burners, electric paint strippers, hair driers or fan heaters can be used to dry out lower sections, but it is much better to be patient and avoid the inevitable unevenness in moisture content which results. Use a removable bat with locating pins to allow the work to be dried while the wheel is used for other pieces.

Throwing in sections

Throwing in sections is another way to achieve scale. Cylinders are a good starting point for as Phil Rogers says in his book on *Throwing Pots*, 'A simple cylinder is the "root" of all upright, tall forms . . .'. Whether sculptural or functional, the basic skills required are the same, and forms are created in the service of an idea. Cylinders can be stacked directly on top of each other, or placed rim to rim. As there is a tendency for cylinders to be thicker and heavier

Fountain by David Frith (UK). It is composed of seven separately thrown sections.

reach great heights which leaves so little clay at the end for a finishing touch.

When inverting one form onto another, use calipers to determine identical sizes. Throw on removable bats but do not wire off the top form immediately. You are then able to use the bat to lift and invert this section to line it up with the lower one. Wire cut the upper form from its bat when satisfied with its location.

Enjoying throwing

Charles Bound (UK/USA) takes a quite loose approach to his throwing. He attributes much of this to an inability to work in a cerebral, refined way. There is a recognition of 'my own limitations' is how he puts it. 'Loose and awkward is how I would define it. For the more I let

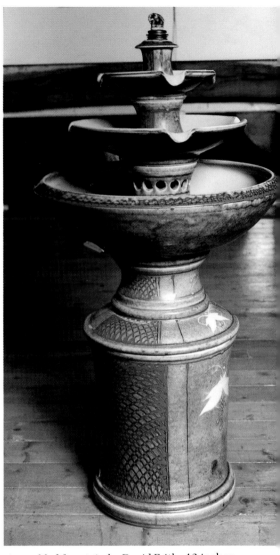

Assembled fountain by David Frith, 43 inches (110 cm) high. Base contains recirculation pump and water reservoir.

go of that (efforts at refinement), the more successful the work.'

For Charles, there is a love of what clay can do – the cracks, dryness that promotes splitting at the sides, building in layers. Pieces frequently fall apart and are picked up and reassembled. Large plates with torn and cut segments, gaping holes

17

Large storage jar by David Frith, 29 x 20 inches (75 x 50 cm). *Collection of the author.*

and spontaneous marks covered in slips and applied bits of clay attest to this approach. Stacked cylinders twist and writhe upwards. Sand and grog additions to the clay are evident in abundance and even his smallest teabowls have surfaces which are full of life. He suggests that his first efforts on the potters wheel only came to life when using 15 pound balls of clay. This says much about personality, where small precise movements are impossible, and a free interchange of ideas and materials exists.

Charles enjoys the challenge of pushing large lumps of clay around and when watching him work, I am reminded

Large plate by Charles Bound, 24 inches (60 cm) in diameter.

Footprints on pot by Paul Soldner. *Collection of the author.*

of Peter Voulkos and the recent California description of centring as '*muscling the clay*'. I wish I could say there was an easier way to do this, but a wiry strength and determination, coupled with lots of practice, seems to be the only solution if you wish to work this way. Of course, coils can be added to rims for additional dimensions and to the footring when turning.

Paul Soldner (USA) illustrates yet another approach in his recent work. This is to use the wheel as a tool to create slabs and forms for further work. The basic cylinder becomes the source of shapes to be manipulated, cut up, indeed walked upon, and reassembled. Slabs made in this way may also take advantage of the throwing ridges to create linear patterns across the surface.

Avoiding cracks

A few thoughts on avoiding 's' cracks in the base of large plates:

1. The clay must be firmly compressed for strength, and one way to do this is to centre the lump, compress it into a thick disc, then cut it off and turn it over, repeating the process so that both sides are pressed firmly down.
2. Try the Japanese approach, which is to pound the lump into the centre and open it up with a rhythmical thumping of the fist as the wheel slowly rotates. This will get the ball of clay roughly centred, well-compressed, and ready to throw without huge muscular effort.
3. As with all large works, additions of sand or grog will lessen the shrinkage and therefore the stresses involved.
4. Wire cut the work free of the wheel-head immediately and repeat this several times as the work dries to the point of removal from the bat.
5. Dry slowly and evenly. Try sanded bats and slatted drying racks. Dry rims will cause the damp centre to contract outwards, with disastrous results. The finer the clay and the larger the piece, the slower must be the drying. Australian Greg Daly tells me that he manages large porcelain

plates (about 60 cm across), when allowed to dry over a period of *several months.*

Slabware

Slabware has certain advantages over other methods: Large surfaces can be created relatively easily and whole sections may be created on the flat, then erected into a vertical position when dry enough to support their own weight. This means you do not *have* to work from the base up as with coils and wheel work. When you do build up, small slabs may be combined with coil methods for a faster result. Sheets of clay may be used spontaneously or patterns made and the pieces assembled according to considered plans and designs. I also like the way that a slab resembles a skin that may be stretched into a form.

Slab preparation

Creating slabs gives the material dimensional characteristics – length, width and thickness. When firm, they can be related to construction experience with sheet building materials, or if soft, experience of dealing with fabrics. Slabs can be made in a number of ways: hand rolled with a rolling pin, wire cut from a block of clay, pressed or pounded out, stretched by throwing repeatedly onto a table or floor, extruded, or made with a slab rolling machine. My own methods include a combination of these, but most often I use an old washing mangle which has been converted into a slab roller.

In addition to the dimensions created by slab preparation, two other important features appear: *edges* and *surface qualities* which result from pressures and stretching. Textured cloth and paper, or

any absorbent material can be used as a work surface and rolled onto the clay. Receptiveness of clay to impressions is one of the characteristics that make it such a wonderful material to work with. As Coll Minogue says in *Impressed and Incised Ceramics*, the ability of clay to retain impressions and marks, and the knowledge that, when fired, it will last indefinitely, has attracted people to this medium throughout history. And there

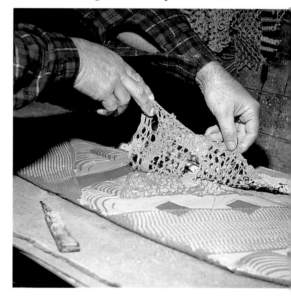

Coloured slips and cloth textures are applied to slabs.

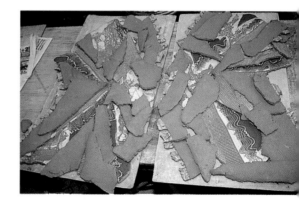

Detailed and plain slabs are collaged together.

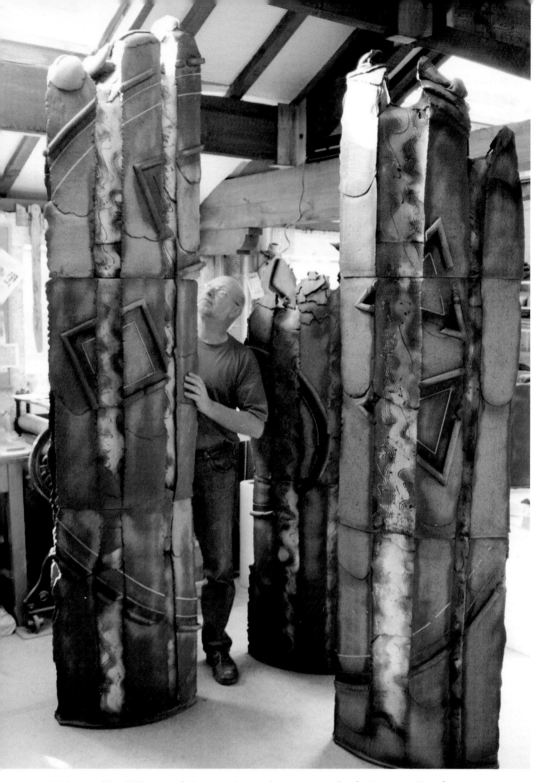

Trial assembly of 'Elemental Concerns', a sculpture group for the Leicester Royal Infirmary, by Jim Robison. Coloured slips and cloth textures are applied to slabs.

are artists for whom the process of working the clay surface becomes the major part of the overall artistic statement.

Working method

Certainly, for me, the act of slab rolling has become an essential part of the making process. When I prepare for work, the first task is to make slabs – a lot of them. They are made to dimensions required by the size of the proposed work and left to stiffen a bit on several layers of newspaper. For larger projects, slabs may be stacked up with paper in between and covered in plastic until needed. The old mangle I use, like any slab rolling machine, requires a cloth to keep clay from sticking to the rollers. The choice of cloth, or combination of materials will transfer an immediate richness to the clay surface. The act of rolling causes the clay to stretch, and this is revealed clearly along broken edges. When slabs are folded over and re-rolled slightly thicker, the edges are increasingly activated. Responding to pressure, they tear into

fresh and spontaneous shapes that suggest geological events and the ageing process.

Assembling a work

Slabs are prepared, textured, painted with slips and collaged together at a soft to leatherhard stage. The combined pieces form sheets that make up the sides of vessels and sculptures. Laid on paper, these are allowed to stiffen in curved supports made from hardboard.

When leatherhard, the curved supports are raised into a vertical position on a base slab and the clay sides joined to each other at the edges. To provide additional support, lengths of wood are sometimes temporarily attached to the inner sides with soft coils of clay. When slabs are fairly stiff, joints must be carefully made. I use a kitchen tool, an onion holder, which has long pins like a

Sides of large pieces are placed in hardboard forms until leatherhard. Wood slats are attached with soft coils to prevent sides from bending when stood up.

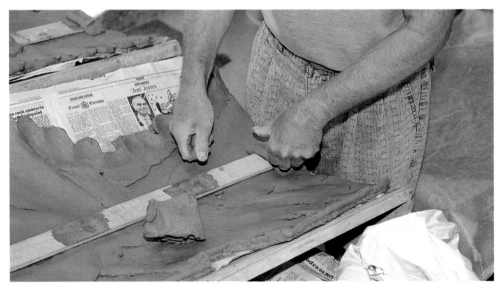

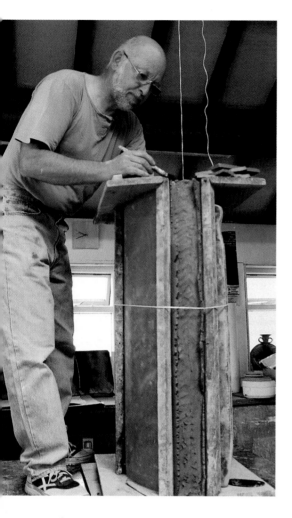

One of the eight Leicester Royal Infirmary sections during construction. Hardboard forms tied together for support during the joining of sides. String in the background is a plumb line to insure absolute verticality.

Below
Top of section is refined to fit hardboard pattern. This pattern will then be used to make the base of the next section.

comb to score the edges. A stiff toothbrush, dipped in water, is also useful. Slip is commonly used, although I find that water softens the slabs faster and a soft coil, worked in, makes a secure join.

Multiple sections

When making pieces which rise beyond the four foot (120 cm) height of my kiln, multiple sections are in order. I don't really mind joints when they have been thought about and planned for. Another factor in my thinking is *what can I lift?* – especially as there is a set of stairs between studio and kiln room. With an assistant, substantial chunks can be manoeuvred (and I admit to cries of 'help' when the time comes to load the kiln) but on your own it can be quite a struggle. I can't think of many things worse than having a completed piece, dried and glazed, broken on its way into the kiln!

With sections and weight in mind, my largest hardboard formers are about 1 metre (39 inches) tall. For the Leicester Royal Infirmary commission, three of these were placed end to end on tables running the length of the studio. The

slabs for the piece were curved and laid face down on paper, in the formers, according to the model prepared from scale drawings. Combed slip was a feature which ran from top to bottom and treated as one piece, the patterns could be arranged for the full three metre height while in a horizontal position.

Once satisfied with the arrangements, the piece was cut into its three parts. These parts were assembled like individual sculptures – two half shells were brought together with bases and the tops cut to size with the aid of paper and hardboard patterns. Some shaping, modelling and slip painting were required to finish things off. The entire work, less the wall relief, comprised some ten sections. It was then dried, spray glazed and fired (two sections at a time) to 1280°C in a reduction atmosphere.

Installation

The tall columns are designed so that threaded steel bars may be inserted through them and anchored into a floor or base of some kind. On the top, nuts and washers tighten the columns down to the floor. In some cases, the ceramic sections are also secured with silicon mastic or a thin cement mix. And if exterior durability needs to be guaranteed, they are perhaps filled with concrete.

Marlis Lischka (of the former East Germany) uses a combination of coils and slabs in her large 'Wachter' series (Watcher, Sentinel or Keeper). She creates lively compositions of shapes which take advantage of the painterly and textural qualities possible when using slips and

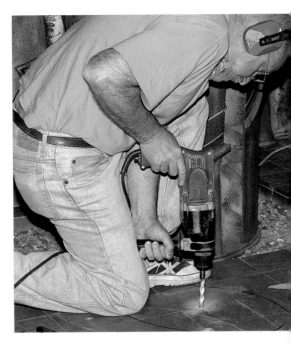

Floor is drilled for rawl bolt type anchor. Threaded bars ½ inch (12 mm) in diameter, 9 feet (3 m) tall will hold columns securely in place. *Photograph by Sasha Andrews.*

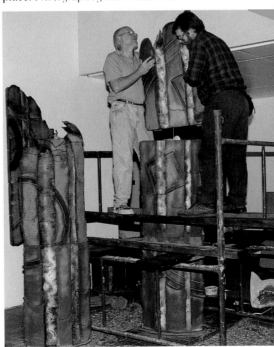

Scaffolding in place. Jim Robison and assistant, Tony Mosley, lift upper sections into place. *Photograph by Sasha Andrews.*

25

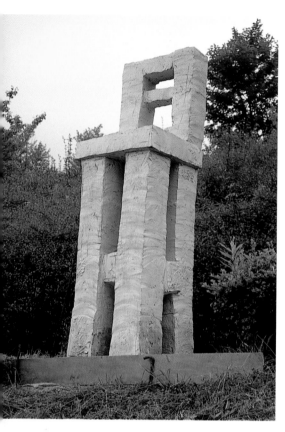

'Yellow chair' by Sandor Kecskemeti. 8 foot (250 cm) high. Ceramics Cultural Park, Shigaraki, Japan.

Right
'Sentinel' ('Wachter') by Marlis Lischka, 78 inches (200 cm) high.

glazes. Some of these pieces, towers and gates, use light and dark areas to present optical illusions that distort form and tease the eye.

Nora Kochavi and Naomi Bitter, (Israel) are a long-established team (since 1961) on the ceramics scene. They are known both for the scale of the work, and its rich philosophical content. Influenced by Jewish culture, images nevertheless speak to a more universal human condition. A note in the Beer-Sheva

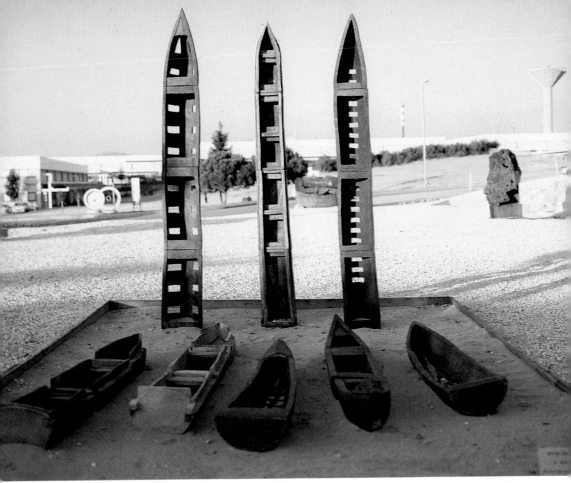

Boat forms in Israel by Nora Kochavi and Naomi Bitter.

Biennale catalogue explains: 'handbuilt boat forms on the theme of escape centre on the desire to escape from some state of being and one's inability to do that. The boat which, in various cultures, serves as a mode of transporting the dead to the world of the hereafter, continues roaming through space and time.' Further poetic thoughts included:

A boat light as a bird's feather
A boat heavy as a bier
A boat in the ocean of Space and the
 river of Time
A boat in the deeps
A boat that is a prison
A boat that is a temple
A boat that makes way for hope

As the scale of work is usually larger than their kiln, it is made in sections and secured after firing. In recent years, most of their work is environmental and as such, their arrangement in space is flexible and lends itself to many variations.

Sándor Kecskeméti (Hungary) uses clay in an altogether massive fashion. Large blocks of clay are shaped by throwing a substantial lump repeatedly onto a table or floor. Sándor enjoys the mass itself and the visual record of pressures and distortions that occur as clay blocks are banged forcefully together. Layers of grog or powdered clay are spread on the surfaces to dry the blocks

Body parts cut out of slabs and curved into form by Martin Hearne.

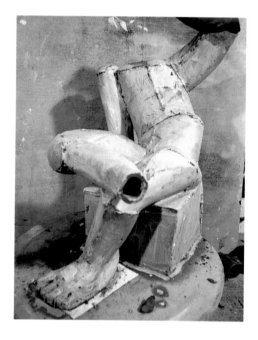

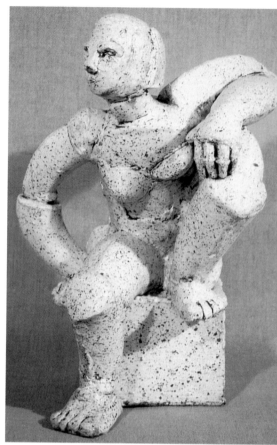

Left
Partly assembled figure by Martin Hearne.

Above
Completed figure by Martin Hearne shows signs of construction. Note segmented aspects and unrefined seams.

and prevent them from sticking together.

Martin Hearne (UK) is known for his slabware figures. These illustrate the careful approach of a skilful pattern maker. Extensive life drawing is followed by clay slabs; designed, cut and assembled into sections of the figure. In some instances, clay supports are built into the figure during the making. These are lightly attached so that they can be removed after bisque firing.

Using moulds

For some determined souls, working in sections will never have the appeal of the single object, and it has to be admitted that many multi-sectioned works are designed to appear as one. Building up in coils and slabs, or throwing in sections, will provide ways of reaching upwards

and outwards in fits and starts. Another approach is to provide support for the work while it is in the formative stages. My own descriptions of slab work use hardboard supports for a simple curve, and this enables large vertical pieces to be achieved once the clay has become leatherhard. For more complex forms and for multiples of the same shape, plaster moulds offer a better solution.

David Cohen is an American who came to the UK, studied sculpture at Edinburgh and stayed long enough to teach there and ultimately became Head of Ceramics at the Glasgow School of Art. His awareness of Fine Art values, sculpture traditions, and love of ceramic media, has resulted in a body of work which jumps the conventional boundaries between these areas.

He has chosen to focus upon the 'austerely circular plate' for his recent exhibitions. On these plates, fruit has been a favoured theme, particularly the apple of biblical temptation. Also within this format, he plays with complex geometry and as the art critic, Cordelia Oliver put it, he has found 'the matrix for a long and impressive flowering of ideas in which signs and symbols are made to carry intimations of the seasonal, as well as the human cycle of life and death. In this tragi-comedy . . . Eve's apple plays a starring role, whether as symbol of fertility, sensuality and voluptuous maturity or as a portent of decay and inevitable corruption.'

His slipcast plates are arranged in compositions which are designed for each gallery venue. Individual plates have a finished size of 12 inches (30 cm) in diameter and one arrangement may contain as many as 135 plates. Casting in

such quantity, David has opted to use commercially available slip from Stoke-on-Trent suppliers. Similarly, his gloss glaze is of a manufactured variety, although fired to 1140°C, well beyond its specified 1060°C. To contrast the white earthenware slip, some plates are cast in a black slip of his own making.

Frank Steyaert (Belgium) is perhaps best known for his amazingly detailed containers in which magical interior spaces are revealed beneath intricately patterned lids. He also collaborates with Dirk Steyaert on architectural projects and the design of sculptural furniture. One extraordinary body of work records his 'Hommages' to ceramicists whom he

Detail of 'Tree Plates' by David Cohen.

admires. At least 20 potters are represented by these pieces and each captures something of the essence of the person and their work.

Frank starts by building the underside of the work. When satisfied with the shape of this, a mould is made. The mould clay is removed and the lengthy construction process of the new container begins while the plaster mould is still wet. When the clay work is finished, it is kept wrapped up in this

Above
'Geometric Tree' composition of slipcast plates by David Cohen.

Right, above
'Large plate' by Claudi Casanovas, 58" (147 cm) dia. Strata due to a mixture of clays. *Photograph courtesy of Galerie Besson.*

Right, below
'Homage to Colin Pearson' multi-lidded container by Frank Steyaert, 48" x 20" x 24" (120 x 50 x 66 cm).

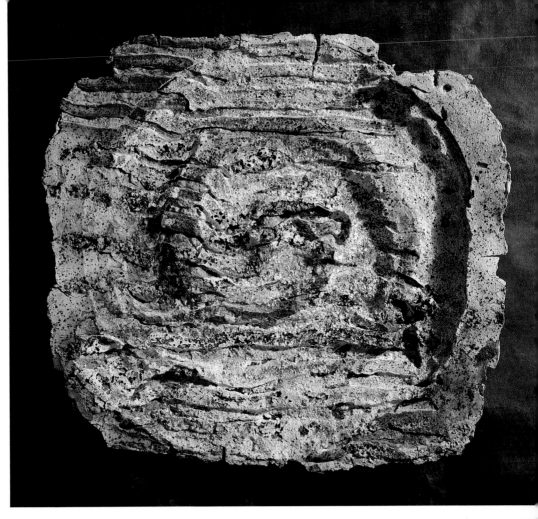

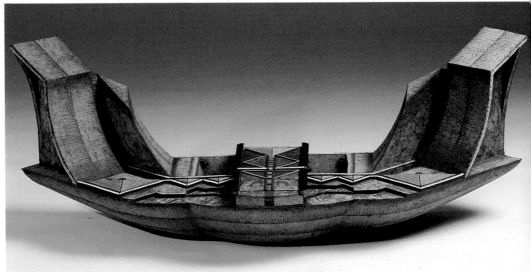

'Homage to Colin Pearson' in progress. Note precision with which detail are constructed prior to assembly in a plaster mould.

An inverted base is made first. Then a mould is taken and the work is built inside the wet mould. These containers with elaborate lids by Frank Steyaert are then left to dry slowly (up to 3 months) inside the mould.

mould for approximately three months. This allows the work to dry very, very slowly to a leatherhard stage. Only then is the work removed from the mould and the underside finished completely. Drying continues at this slow pace to avoid any cracks.

Surfaces are treated in a variety of ways, engobes being a favourite, and the containers are fired to 1085°C in an electric kiln. Individual parts may be treated differently – raku fired, smoked, or lustre glazed. Occasionally, other materials such as glass, wood or stone are incorporated.

Claudi Casanovas, a Catalan, impressed the British at the International Potters Camp at Aberystwyth in 1991, with the inspirational scale of his plates and the ingenuity of his working methods. To make 5 foot (150 cm) diameter sculptural dishes, you *need* a source of inspiration, strength and ingenuity.

His inspiration comes from the mountainous landscape of Northern Spain. Rock strata, in particular the multi-textured, multi-layered results of molten volcanic action, seem to be especially significant – different rocks sandwiched together in the heat, and eroded through time, display earth colours, fissures and a smooth matrix of glass against coarse, sandy surfaces. And the resulting work, as reviewer Jane Norrie put it, 'has surfaces corrugated, indented, speckled, ridged and gouged, mimicking erosion, making you think of the earth's crust'.

His clay is difficult to describe, as there is *no one* clay. The use of high and low firing clays together would seem to defy good sense, and to do as he does, mix as many as 12 different clays together, downright eccentric, except that the results are so beautiful. The clay is continuously altered and improvised, as he experiments with combinations that include coarse and fine sands, grogs, colourants, stones, metal, glass. Combustible materials are also added to alter texture and colour. these include sawdust, olive pips, straw, twigs and flour. The variations in all these materials are further emphasised by a post-firing sandblasting. This breaks through surfaces to reveal inner textures and

causes ridges of harder clays to stand out against softer areas.

Ingenuity is evident in his mouldmaking techniques. To begin with, two circles of heavy polythene sheeting (about 150 cm or 5 feet in diameter) are heat sealed together at the edges to form a large bladder. A small tube is inserted and attached to an air compressor which is used to inflate the bladder into a dome-like shape. Casanovas covers this dome with strips of plaster-soaked hessian. Multiple layers are applied to gain the thickness required to make a self-supporting mould. When dry, a hand-guided fork lift truck is used to move the mould onto a specially made iron table which holds the mould firmly in place and allows it to be rotated. When the plaster is next turned the other way up, it becomes the mould for a rigid dome made from a two-component polyurethane liquid foam. This rigid dome is the base on which the large dish is formed.

Experimental mixtures of clay are applied, using cross-sections of laminated strips to create linear movements over the surface. Three-dimensional variations are initiated by paper wrapped shapes in clay or polystyrene pieces which will be removed later. When satisfied with the arrangement and thickness of the clays, the work is allowed to harden.

When relatively firm, another plaster support mould is applied to the back of the plate. This is fastened into place on the rotating table and then turned over so that the interior may be further worked. To modify relief surfaces, clay is applied or removed until the work is completed.

Unusually, the ceramic work is not only supported in the working stages but

Large plaster moulds are made for each piece.

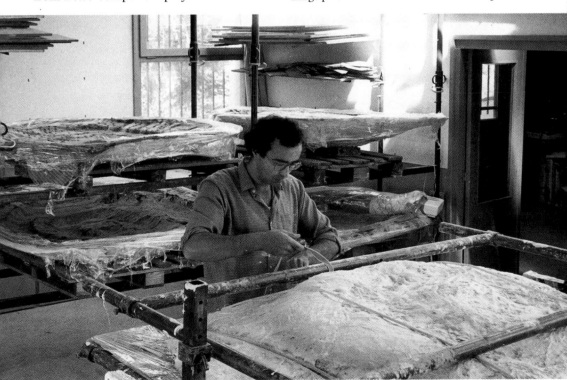

throughout the process. After drying, the mould allows a fork lift truck to safely transport the piece to the kiln where it continues as a support during the firing. The kiln is one he built himself and is a variation on a large, square top hat, with an oil burner at each corner. The loading of the dishes is aided by inflated bladders made from truck inner tubes. These hold the mould off of the kiln floor until the fork lift has been removed. When slowly deflated, they lower the mould gently into place.

Gudrun Klix (Australia) has a number

Special rotating table allows mould to be inverted and work carried out on the other side.

Below
Claudi Casanovas loading top hat kiln using a fork lift. Moulds are supported and fired to stoneware temperatures with the work in place. *Photograph courtesy of Galerie Besson.*

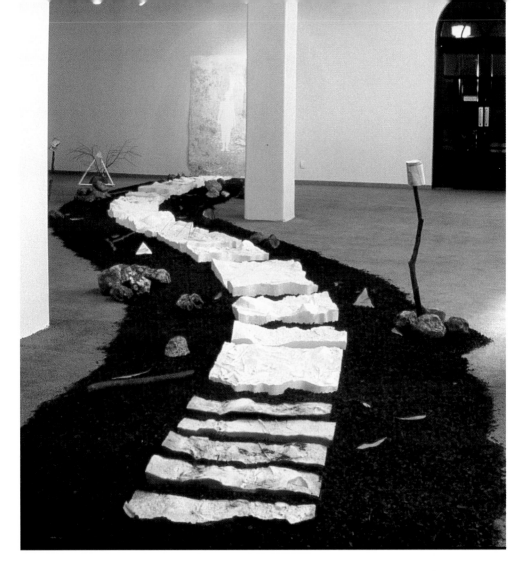

of approaches to her larger ceramic and mixed media 'installations'. In 'Path Edge/Mind Edge', she, with helper, Oliver Burkhardt walked miles with bags of plaster and water to cast large sections of the Shoobridge Track in the bush of Tasmania. The footpath becomes both a real record of place and event, and a metaphor for life. As she puts it, the track is 'unpredictable and ever changing, always affected by outside influences and yet continuing in a direction that is set through some unconscious process . . . We can look behind and see where we

'Path Edge/Mind Edge' by Gudrun Klix (Australia). A cast clay and mixed media installation, 30' x 6' (9 x 2 m).

have been, note the markers that we did not recognise . . . Looking ahead there is only a void filled with desires and imagination.'

The plaster moulds, 45 to 90 cm (1½ to 3 feet) in size, were used to slipcast path sections. Many hours were spent removing twigs and stones, and filling undercuts before casting. A similar number of hours was spent carving these

filled details back into the cast clay. Real objects, 'markers' found along the way, were included as part of the work. The cast pieces were left white and unglazed to underscore abstract qualities of the work.

Pip Warwick (UK) works in a figurative vein, with memories of the Pop Culture of the 1960s, Rock and Roll, and Show Business personalities very much in mind. Formal sculptural concerns surrounding the figure, intimate knowledge of his subjects, and years of determined study of ceramic processes have given Pip an ability to express intensely held ideas through these life-size ceramic sculptures. He admits that the problems of working on this scale puts many people off. Unlike many media, the knowledge of techniques and chemistry must be learned over several years. The sheer time-scale of endeavour and disappointing results along the way will cause many to turn to more

Left
Gudrun Klix walked miles with plaster and water to cast sections of the Shoobridge path in Tasmania. 'Path Edge/Mind Edge' becomes both a real record of time and place and a metaphor for life.

Below
Detail showing extensive work necessary to emphasise leaves and twigs.

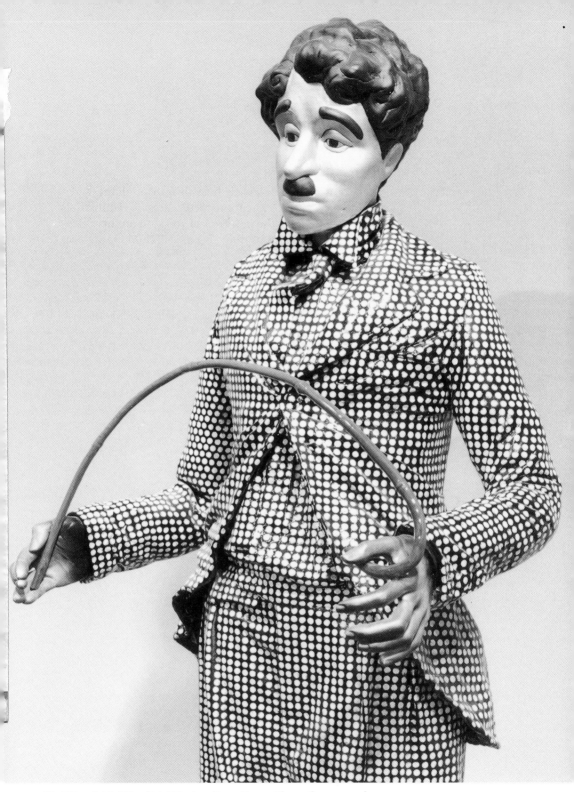

Pip Warwick's 'Charlie'. Life size slipcasting with earthenware glazes.

immediate and easier media. On the other hand, he expresses surprise that, as clay is undoubtedly among the oldest sculpture materials, there are so few sculptors carrying on in the life-size figure tradition. He feels that clay is both 'alive and satisfying'. What other material has such 'sensual and sensitive qualities'... and the 'array of different glaze and decorative techniques allows the introduction of colour and finish ... and being ceramic, fit the form in an exact and desirable way'.

Pip feels that plaster is 'dead' and when cast and 'resurrected' in metal, remains so. This, from someone who has such ability with plaster, I find quite intriguing. A number of ceramicists,

Peter Voulkos and Stephen DeStabler among them, have decided to 'go for bronze' when the occasion has presented itself, and to move between different sculptural materials can offer great pleasure to some.

Pip begins with drawings of his subject to clarify pose and gesture. He may make maquettes before embarking on the life-size solid figure built on an armature. This solid figure will be very general, and from this a plaster 'press mould' will be made. This is a departure point from many sculptors who would perfect the solid to be cast (perhaps in another medium). The press mould that may amount to 20 interlocking parts is assembled, and slabs of wet, plastic clay are punched in to ensure an accurate

'Death Rider' by Pip Warwick (UK). Modelled and cast earthenware and stoneware with precious metal lustre finish. 1½ times life size.

cast. The mould is parted when the thick clay (about 3 cm or 1¼ inches) is dry enough to support its own weight but wet enough to be worked on. Pip can now work on the figure with complete flexibility, able to make the most dramatic changes, building up or carving down as desired.

When finished in detail, a final intricate 'slip mould' is made. This may contain over 100 parts that interlock on assembly. The solid is removed, and the cleaned mould parts joined together with scrim soaked in plaster. Joints must be strong and not leak under the force of some 30 to 60 gallons of liquid clay with a weight approaching 5 cwt. When the mould has absorbed enough water to attract a clay thickness of about ¼ inch (½ cm), the remaining slip is drained out from a hole made in the bottom of the mould. The figure is removed to allow final modelling and refinement.

At one time, Pip made the figure in sections and joined them together at the leatherhard stage. However, he now prefers to cast the entire figure in one piece. A fine casting slip is made from plastic clay bodies such as red earthenware, buff stoneware, ivory white, or even porcelain. Grogged bodies are not used due to the roughness of the final surface when sanding or rubbing down.

The density of the clay and the varied thickness of the sculpture (fingers may be nearly solid) mean a very slow drying and firing process is required. In preparation for firing, the kiln is pre-heated to 50°C before the work is put in place. Then comes gentle warm to 100°C for 24 hours, followed by a 48 hour rise to a bisque temperature of 1120° to 1150°C. A gentle cooling is also recommended – he fires down to control the speed, over another 48 hours.

Glaze is a smooth transparent earthenware fired to 1080°C. His love of lustres is evident in the extensive use of gold and silver. Made from a mixture of lead-based glaze and soluble salts – gold cloride, silver nitrate and bismuth subnitrate – these colours fire at about 750°C in a carefully controlled, heavy reduction atmosphere. Soot is washed from the piece at the end of the firing.

As the piece is large and delicate before firing, Pip sometimes gives the dry clay a couple of coats of fibreglass resin to strengthen it. This enables the piece to be safely moved into the kiln. The fibreglass burns off during the bisque firing – with a rather unpleasant smell though! After glaze firing, the work may again be reinforced with resin – on the *inside* this time. Chopped strand fibreglass is mixed with the liquid and funnelled into the work through the heel perhaps, or another invisible location on the up-turned figure. This gives the work sufficient strength to travel and be exhibited without fear of damage.

Bronze and other casting methods

The use of clay to create models for casting is, of course, quite a common practice. Plaster, concrete, and fibreglass resin are often used. However, in many cases, where the end product is metal, the clay appears to have lost its freshness and vitality through over-work and concern for the mouldmaking process. It is encouraging, therefore, to see ceramicists who have successfully taken their ideas into this material. Peter Voulkos has explored this avenue as has Stephen DeStabler. When DeStabler was asked for his reasons for casting, he indicated a desire to create dynamic

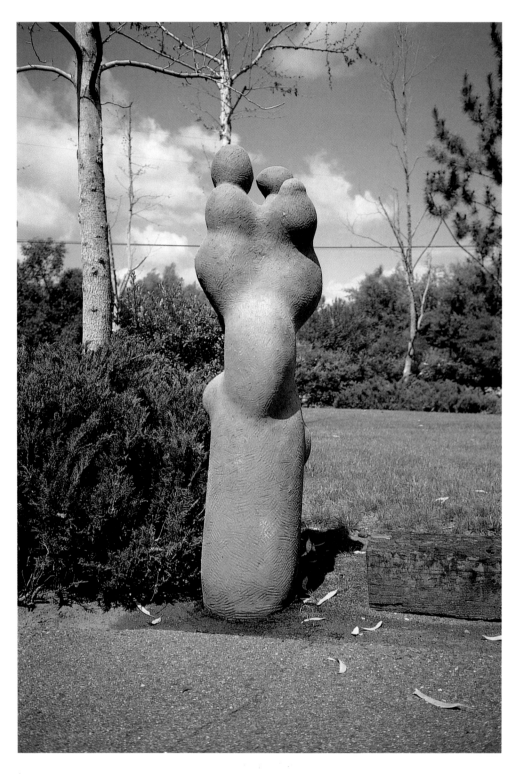

figures free from any supporting mass. Indeed, the figure I saw contained the surrounding blocks for which his work is known, but only around the upper body, and this weight was supported entirely on the delicate ankle of one foot.

Other ceramicists who have taken to casting are Jerry Caplan (USA) who was invited to turn one of his clay pipe sculptures into bronze as a permanent memorial outside the Pittsburgh Arts Center, and Frank Boyden (USA) an artist who enjoys the challenge of large mouldmaking. He responds to the environment and yet strives to retain all of the qualities which are so much a part of freshly manipulated clay. Frank gives the following description of the making of a large bronze casting from a clay original:

> This piece was made as a result of finding a blade-shaped rock which was part of a blasted cliff face along the Columbia River Gorge highway in Washington State. I succeeded in making a mold from this stone face and produced a positive wax of its exact shape and dimension. The wax lay in the mold and I built the remainder of the piece from solid clay, approximately 700–800 pounds. Clay was built up to the thickness I wanted and then I threw large cylinder forms, ripped them open and threw them out on the cement floor, stretching them to about ½ inch thickness. This exposed the compression marks from throwing producing long striations in the slabs.
>
> Starting from the bottom I laid the slabs up the piece as one would lay shingle on a roof working to make the striations of the clay visually fluid as they moved from bottom to top. When

'Stretched pipe' by Jerry Caplan. Some of his work has been subsequently cast in Bronze.

this was done other pots were made, decorated with heavy incisions, torn apart and pieces of them inserted through the covering slabs. The clay was textured on one side to look like stone and objects such aş salmon bones were embedded in the surface.

> When the clay surfaces were complete a single polysulfide rubber mold was made of the entire clay surface and a single large plaster and steel Rebar mother mold over that.
>
> The mold was pulled off, cleaned and a wax produced from this mold. The starting wax made from the cliff face mold was attached and the entire piece was completed in wax. It weighed only 40 pounds and I filled it with styrofoam pellets so it wouldn't collapse and transported it 400 miles to the foundry. The piece was cut in three sections, cast and welded back together and given a patina.

Reasons for casting

Reasons for casting vary, but among them are:

1. Permanence; with weatherproof and vandal-resistant features.
2. Structural versatility; strength in clay is a feature of fired mass and considerable thickness may be required to support a given structure.
3. Design flexibility; the strength of metal allows delicate features and asymmetrically-balanced masses to be created without fear of breakage. Plastics have the advantage of low weight. Without shrinkage, internal armatures may be used. And without firing, uneven thicknesses may occur at will.
4. Status; there can be no doubt that many people still view bronze

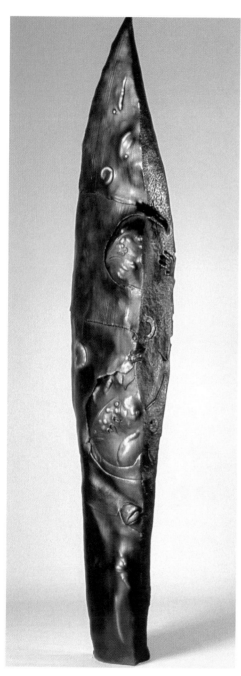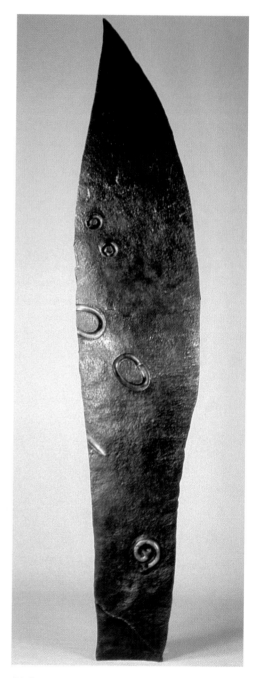

Above
'Columbia Blade 91', bronze casting from clay sculpture by Frank Boyden (left, front view; right, back view) (350 x 36 x 64 cm). Cast bronze from cliff face and thrown clay segments.

Right
'Agamemnon' of the Trojan War series by Anthony Caro, 70" x 25" x 12.5" (178 x 63.5 x 32 cm). Stoneware, jarrah wood and steel. *Photograph by David Buckland.*

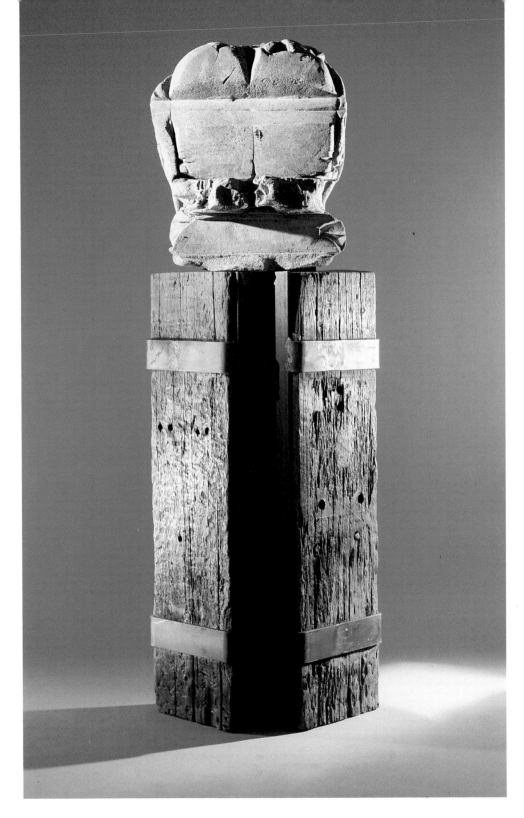

sculpture as 'real art' while ceramic sculpture remains hovering in the neighbourhood of 'craft'. Hopefully, these demarcations, which have begun to blur, will one day disappear.

Mixed media

The love of clay as an expressive substance grows out of a response to the properties of materials and processes, and many ceramicists are fiercely defensive of clay as an artistic media. Others, including painters or sculptors from differing backgrounds and experienced in other art forms, are less worried about any particular 'truth to material' and feel free to engage in artistic endeavours which express ideas through all manner of media. Ends justify means and when 'ideas' are paramount, then paint, wood, metal or stone may find themselves alongside clay as the conveyor of an artist's personal messages.

Anthony Caro (UK), long-time assistant to Henry Moore and known for his large steel sculptures, has recently completed a vast project of some 38 sculptures on the theme of the Trojan War. Each of these pieces represents a character from the epic poems of Homer and collectively, they filled the gallery at the Yorkshire Sculpture Park with a powerful and foreboding presence.

Heavy chunks of wood and sections of steel were combined with large masses of clay in a bold and forthright fashion. Caro worked in France, at the studio of Hans Spinner, located in Grasse on the Cote d'Azure, north of Nice. He was encouraged by this dynamic ceramicist (who has worked with many artists, including the painter, Miro) to use large blocks of clay in his creation of massive forms. Developing ideas in this way, the organic nature of the plastic clay was recognised and used effectively to suggest the heads and personalities of Olympian Gods, the Achaians and the Trojans.

Julius Bryant, in his essay on Caro's Trojan War, reminds us that this is not his first experience of clay. In the 1950s, he produced bulky human figures inspired by the random shapes formed by dropping and hitting soft clay. 'A rough, unfinished appearance resulted after casting, which retained the sense of the artist at work, a process of creation that now seems akin to the "truth to materials" and "direct carving" ethics associated with Moore and Hepworth.' Again in 1975, participation in an artists' workshop in Syracuse University, New York, resulted in 'sculptures that took the customary vessel forms of ceramic ware, sliced them and then combined them like still lives by Cezanne or Braque'.

What is new in The Trojan Wars are the freely-manipulated forms. The addition of large amounts of grog to the clay body (as much as 60%) meant that Caro could stick with solid volumes. Avoiding the technical necessity of hollowing out before firing, he was able to retain spontaneous effects. 'I worked very loosely, intuitively,' Caro says. 'I allowed the clay and the lumps, what Hans call "the breads" to take me. We pushed and beat things into the clay until an image began to emerge.' After what appears to be a minimal oxide wash or spray, the pieces emerged from the stoneware kiln with added drama due to tonal variations created in the firing.

The wood and metal elements act as pedestals, and may seem a contradiction of Caro's characteristics. But working back in his London studio, Bryant says 'each pedestal became an integral part of

these volumetric sculptures, some supporting intricate steel compositions appropriate to the emerging identities'.

Marion Held (USA) is another sculptor with a powerful vision. Through dark and sombre figures, she creates sober images that evoke the mysteries of life and death. Stoneware bones and body parts are stained with oxides and combined with wood and steel to enable structures of considerable size to be made. After her experience of working in a factory setting in Beer-Sheva, Israel, she has further

'Passages' by Marion E. Held, 25' (l) x 5' (w) x 2.5' (h) (7.5 m x 154 cm (w) x 76 cm (h)). Clay, wood, metal, rubber and cloth.

Left
Hollow Figure by Marion E. Held, 72" x 42" x 15" (173 x 97 x 38 cm). Stoneware and wood.

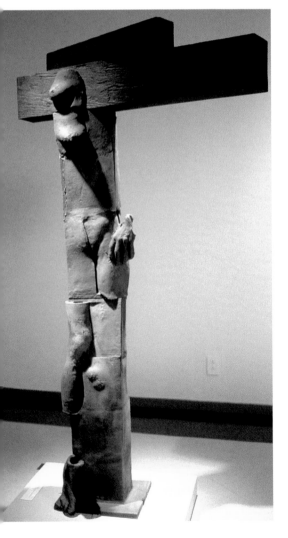

increased her vocabulary of other materials to express her ideas.

In 'Passages' a 24 foot (738 cm) long series of plywood modules act as chest cavities containing objects of contemplation. In an attempt to evoke a transition from one place or state of mind to another, ambiguity is introduced in the form of combinations and permutations of clay, metal, cloth, rubber and wire. As

45

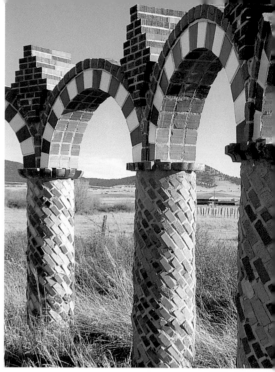

Above
Models of proposed sculptures in Robert Harrison's studio. Planning is crucial for the success of large scale constructions on site.

Right
Detail of brick and tile arches constructed by Harrison for the Archie Bray Foundation in Montana.

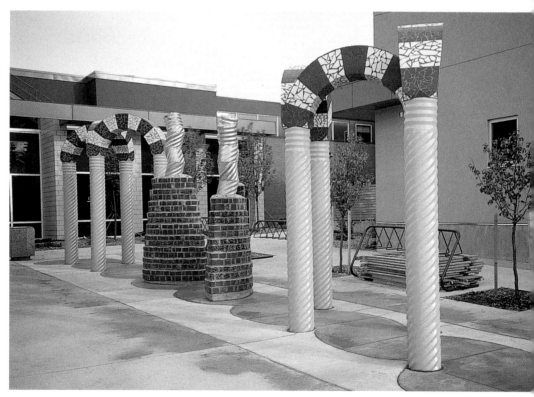

Large constructions by Harrison, which include brick and tiles are more reminiscent of architecture than our usual concepts of sculpture.

Held puts it, 'a ceramic form can suggest a breast or a grenade; others are phallic / bone / or pipe bomb. Some are wrapped in tinted gauze suggestive of bandage or bondage. "Passages" has a particular resonance in a world of Holocaust museums, Rwandas and Bosnias.'

Robert Harrison (USA) is one who has boundless energy and a builder's enthusiasm for enclosing space. He makes use of industrial products, such as bricks and tiles, to build arches, walls and colonnades which suggest architectural remnants and personal shrines.

At Clay Sculpt Gulgong, 1995, on Janet Mansfield's ranch, he teamed with Bruce Anderson, of Australia, to make a garden 'sheltering area' which included circular walls and an impressive archway. In this work, clay was in the form of powdered fireclay and ranch soil, added to the concrete mixture prior to casting the architectural forms. Corrugated sheet metal was used to contain the mix and was left in place to provide a visual link to a location noted for its many similarly clad agricultural buildings.

Returning from Australia, he was invited to create a work for the University of Manitoba, in Canada. The 'Red River Passage', a gateway and shelter area composed of brick, tile and corrugated sheet metal, has echoes of the Australian experience.

Harald Jegodzienski, of Germany, is one who never hesitates to combine materials. For each new work, he strives to invent distinct techniques as a basis for expression. He has said, 'the material is the first letter of the content and the technique is the supporting mediator'. Forming is a process of acting and thinking . . . engaging in conversation. His sculptures and installations are therefore 'comments' which report experience and observation.

Chapter Two
Murals and relief sculptures

When seeking commissions, there is great scope for promoting the application of ceramics to walls. The general acceptance of pictures hung on walls predisposes a favourable attitude to this type of application. Both interior and exterior surfaces can be grist to the mill. Exterior walls have often been neglected and really need attention, while interior walls may be spacious, bland and begging for adornment.

Several commissions that I have undertaken have been in response to the request: 'please do something with *that wall*!' For when something dramatic and rather more permanent than a framed print is needed, clay can be the perfect solution. Walls offer the chance for expression on a grand scale without the undue technical complications which can arise when contemplating free standing pieces of a similar size. The mural can be made from flat tiles, slipped and glazed in a painterly approach or rely upon relief modelling to create shapes and forms through the use of light and shade.

Tiles: a semi-industrial example

In the unlikely setting of a modern industrial estate in North Wales, is the successful Craig Bragdy Designs Ltd., a company which specialises in architectural murals and ceramic wall and floor coverings. Founded by Jean Powell and her husband, Rhys, in the 1960s and continuing under the guidance of their sons Nick and Shon, the firm has become highly regarded for their expertise in this field. Their designs are labour-intensive as they are mostly created from small tiles modelled in low relief by a team of skilled workers, although they may also employ specially designed tiles produced for them by selected manufacturers.

All of their work is based on extensive drawing and painting of subject matter important to the intended clients and the location of the work. Each is designed as a unique image, yet they make economic use of manufactured tiles on particularly large sites, such as the underpasses and walls next to roadways. They have had particular success in the United Arab Emirates, Saudi Arabia and other Arab countries where their extensive use of colour and generous quantities of gold and other lustre glazes, have been much admired.

Among the unusual commissions they have undertaken are vast domes for mosques and markets (souk), numerous swimming pools (including those in private palaces and aboard yachts), roadway underpasses and roundabouts, seawater barrier walls, large murals for Dubai International Airport, and a design for cladding the Kuwait Tower, third tallest tower in the world. Recently they have completed a large abstract painting (designed by Australian artist, Michel Santry) in tiles for an office block foyer in Hong Kong.

Studio methods

All of this may seem a long way from the small North Wales pottery studio beginnings of this inventive husband and wife team, yet the roots of this work are still evident in the current workplace. Sheets of clay are worked on the floor, designs applied and cut out by hand. Each tile is cut to a shape related to the design as a whole, fettled and numbered with an oxide wash. A careful plan is drawn before the work is bisque fired and each tile is hand painted with reference to an original watercolour painting before subsequent glaze firings.

When I visited the premises, many of the small hand tools so much loved by potters (bits of wood, wire, shells, stamps, cut sponges etc.) were much in evidence and wooden trays held stacks of small numbered tiles ready for glazing. A recently installed clay mixer, large pugmill extruder, and new trolley kiln were evidence of ongoing developments. (Experiments in making very large extruded tiles were underway with the technical assistance of studio potter, David Frith.) However, the basic principles are still the same, only the ideas have grown with the confidence of experience. An important lesson for all of us here!

Use of bricks

Julia Barton (UK) has taken advantage of existing expertise in the brick manufacturing industry to create her large works. This was as part of a programme to allow artists to use

Craig Bragdy Designs – several murals in progress. Nick Powell, Director, discusses glaze tests with David Frith in the background.

industrial techniques and facilities to explore possibilities and to develop their work in new directions. The Yorkshire company, Ibstock Bricks, provided Julia with raw materials of known fired characteristics, space to work and kilns of

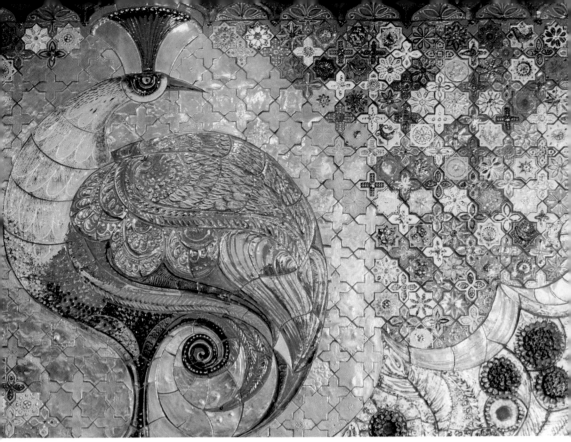

Above
Detail of a tiled mural in a private Arab palace by Craig Bragby Designs.

Below
Individual tiles are numbered and stored in trays to await firing. Murals are bisqued to high temperatures (1150° – 1220°C) and then glazes at lower temperatures (around 1080°C).

Top
Craig Bragdy Designs develops glazes to match the watercolour painting proposal for a Hong Kong office foyer by Australian artist Michael Santry.

Above
Completed mural installed in a Hong Kong office tower. Tiles were large, 18"x 24" (45 x 60 cm) with shapes edged in stainless steel during installation.

sufficient capacity to handle the most ambitious of projects. Slips, oxides and some glazes were also used, and technical advice was on hand when needed. It proved to be a successful venture. Having said that, industrial premises do not provide the warm, cosy atmosphere of an artist's studio and one must be prepared to be largely self-sufficient and flexible, taking the rough with the smooth in the context of a daily working routine.

51

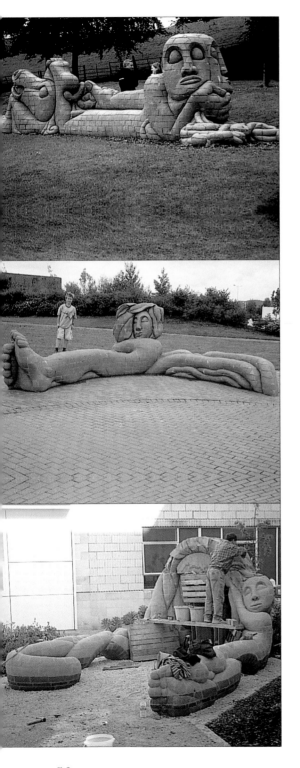

Advantages and disadvantages

Bricks have the advantages of consistent size and an understood relationship with the building industry. They are readily acceptable in terms of durability and strength, making architects, planners and engineers predisposed to accept them. Also, should another brick or bricks be needed to replace damage or re-do sections of work, they will be readily available and can be slotted in with a minimum of fuss and effort.

On the other side of the coin can be the small size of each brick and the necessary mortar joints (about 1 cm or ⅜ inch each) which will take up a sizeable area in any given mural. The mortar joints can be seen as part of the design and tinted mortar is available to match bricks where contrasting lines would spoil a design. The one thing you can't do is *ignore* them! Bricks are also quite heavy and even a small number will require something bigger than the average car to transport them to studio or site.

With all brick work, installation needs considerable care and a friendly brick mason is a valuable asset.

Studio practices

Frank Steyaert (Belgium) applies his skills to architectural settings as well as to the complex sculptural containers for which he is better known. His work exhibits a playful sense of geometry and soft, subtle use of colour well-suited to relationships with the shapes and building materials (brick, clay roof tiles and timber) found in vernacular architecture.

Gwen Heeney carves mountains of raw brick into sculptures based on Welsh Mythology.

Marylyn Dintenfass of New York, creates dramatic wall pieces that bring new meaning to the delicacy of porcelain. By using multiples made from thin slabs, she is able to create volumes as well as shapes and patterns. Energy is obviously not a problem for her as large spaces such as those in offices of the I.B.M. Company or the 42nd Street Terminal in New York City are filled with her exciting, multi-layered compositions of the material.

David Cohen, an American living in Scotland, has related the field of pottery to that of painting and sculpture more closely than most others in this volume. By using an industrial approach to slipcasting plates and then glazing them in related geometric patterns, he is able to combine the pottery production of

Frank Steyaert replacement fireplace (original had been lost) for a 17th century house in Ghent.

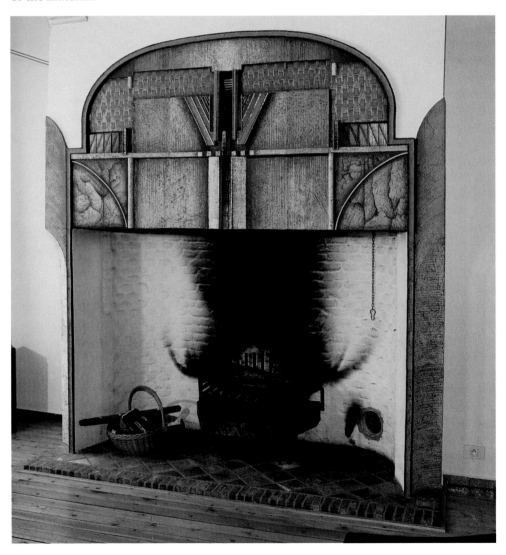

53

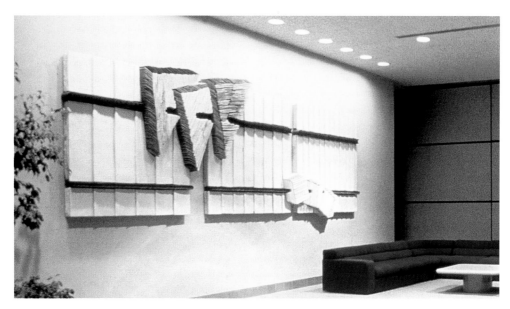

Almost countless thin sheets of porcelain are combined to create this vast wall mounted work for IBM Company by Marylyn Dintenfass.

Left
Detail of porcelain wall mounted sculpture for IBM Company by Marylyn Dintenfass.

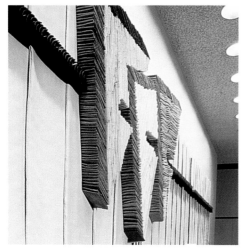

Points to consider

When making wall mounted tiles or relief sculptures for buildings, I tend to look at the location first of all, with practical considerations in mind.

Exterior walls

1. For an exterior wall in a colder clime, they will need to be frostproof and where vandalism might be a problem, particularly robust in structure and design. This means a fairly thick cross-section of clay in the making, perhaps mounted in or backed up with a sand/cement mixture for added strength.

multiples (which are of obviously functional origin) with fine art intentions (thoughtfully arranged compositions which use and unite the circles of individual plates). These works are also seen as exhibition pieces rather than permanent installations. However, as with any architectural application, each one is designed with a specific gallery in mind and may be extended or modified to suit a given space.

54

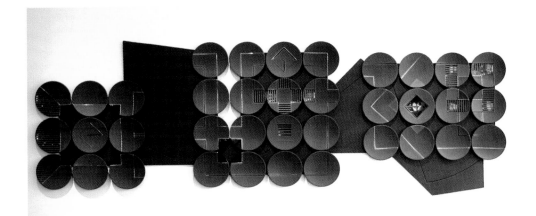

Above

Plate composition by David Cohen (Scotland). He uses prepared mounting boards with numbered hooks for each plate. Each board requires only two support screws to facilitate portability for exhibitions and easy installation.

2. Projections must be limited if within easy reach of viewers and all shapes modelled so as to allow water to run off.
3. Glazes may be selected on the basis of washability, i.e., will the preferred matt surface hold some vandal's spray paint too effectively to be used? Or should it be fluxed just a bit more to smooth things out?
4. Remember your work will change when removed from the confines of the studio and placed in the larger environment. As outside walls are generally viewed from a distance, say by a pedestrian across the street or from a passing car, the imagery will need to be bold and well-defined.
5. If mounted high up on a building, one's perspective will also be changed. Looking up may distort shapes and create unintended angles.
6. Shrinkage can be of critical importance. The move from your

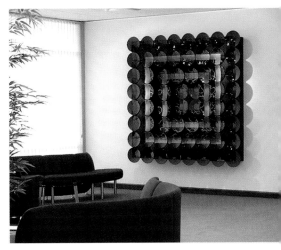

Plate composition by David Cohen (Scotland). Slip casting provides the modular base for dramatic designs created with glazes. They are light in weight and easy to install.

studio to see your work for the first time outside on a building or next to a tree can be a very humbling experience. But it will be far worse if the architect has left an opening in the brickwork for you to fill – and it doesn't fit! The old phrase, 'measure twice and cut once' was never truer. Shrink test each new batch of clay.
7. Never trust an architect's drawings completely. Measure any wall for yourself!

55

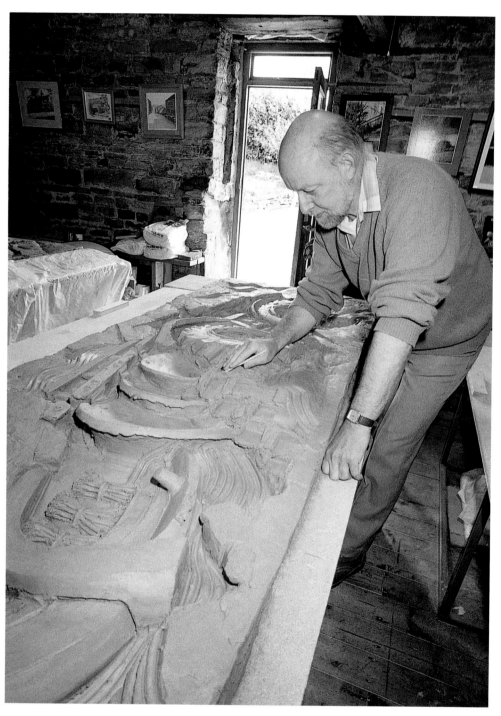

Exterior relief sculptures require bold features. 'Barons Court', one of three panels for the front of a new building in Wilmslow, Cheshire, by Jim Robison.

56

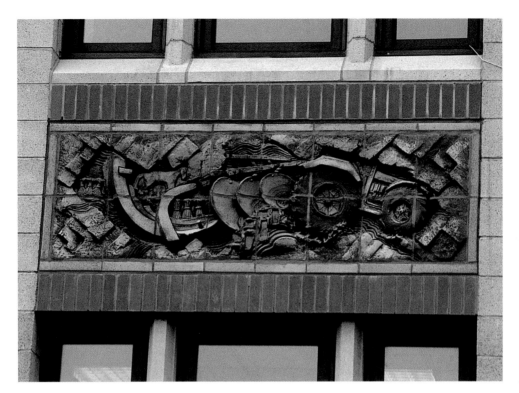

Relief sculpture, 'Barons Court' installed. The view from across the road puts the scale in perspective. *Photograph from Jim Robison.*

Interior walls

1. A protected interior wall can have a much lighter touch. It need not be so robust or heavy.
2. Frostproofing problems do not apply, so you can take a freer approach to modelling, with a more delicate approach to imagery.
3. Interior textures and colours can often be approached, so while bold images must be there to carry at some distance, close up viewing and perhaps even touching should be catered for. It is often this sense of something 'discovered' on closer inspection that will give a work of art its lasting appeal.

Personal approach to design and working method

In my own work, I try to relate to the client's desires and the chosen location for the work, while keeping a reasonable hold upon the aspects of the work which are important to me, i.e. an exploration of the relationships of surface and form, identifiable textures and colours which relate to elements of landscape and the use of geometric configurations to imply the considered intentions of mankind upon his environment. I often include some press moulds of actual objects to root the sculpture in real space and time.

My interior relief panels are generally built up as hollow structures. This does require considerable preparation of the supporting background and ribs before the surface of the sculpture begins to take shape. The design needs to be pretty clear

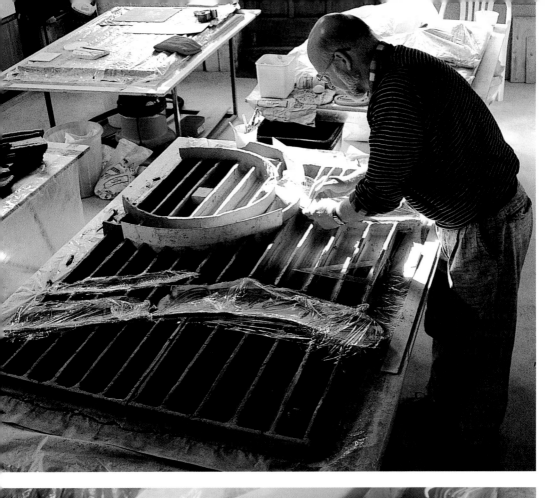

'Success is a Journey, not a Destination' by Jim Robison. Four panels for the Yorkshire Purchasing Organisation. (The cover shows a detail of the second panel.) The imagery on the panels is based on the environment, local industry and client products.

Left, above
The Yorkshire Purchasing Organisation panels under construction. Ribs support the top surface and provide depth without excessive weight.

Left
Details of hollow wall panel construction. A well-scored slab is being readied for attachment to supporting ribs. Note keyholes in background slab. These will provide anchor points during installation. Card or hardboard strips divide individual segments, keeping them separate during modelling.

in one's head so that dividing walls and mounting slots can be positioned before the background is covered over.

An advantage it does give me, however, is considerable volume and depth with minimal weight. With this type of construction there is also an opportunity to break through the surface and reveal an internal structure or hidden object. Slab construction also allows the various elements to be of a similar thickness and thereby reduces the problems connected with drying and firing. And it is worth noting that when there is less weight, it also takes less effort to lift, transport and install the finished article.

Chapter Three
Large on-site works

There are times when it is desirable to create environmental works *in situ*. The reasons may vary from aesthetic to educational but when Janet Mansfield hosted the ten-day Clay Sculpt Gulgong workshop on her 450 acre ranch in Gulgong, Australia, it provided an ideal opportunity to observe a range of approaches and to participate in the creation of monumental works in an incredibly short span of time. Environmental work suggests consideration of a particular site and the creation of a piece sympathetic to it. In Australia, there were no less than 450 acres to choose from. Twenty artists and around 450 participants enjoyed the choice. The selected sites varied from a prominent hill top to a valley bottom, from the remnants of an orchard to placement near the family home and farm buildings, with implied acceptance of architectural influences. The wide range of work undertaken at this event is indicative of the many possibilities in this area and each piece offered lessons in finding solutions to both aesthetic and technical problems.

First of all, look at the demands placed on an artist in these situations; you must study the landscape presented; suggest a sculptural form which is appropriate to both your own ideas and the chosen location; obtain materials (local availability and budget considerations play an important part); create the work of art (taking into account the effects of the weather – sun, wind and possible rain) on the work in progress; dry and fire the work (type of fuel is again often determined by availability and budget); make final siting arrangements for placement of the work and complete appropriate landscaping. And in the case of this event, complete the whole venture in ten days!

As with many large-scale endeavours, it is often best to look at the last items first. Time factors – when is the work to be finished; how is the piece to be fired – in a separate kiln or on location; arranging protection from the weather – is a building available nearby or do you create a temporary shelter; how do you propose to work – in small manageable sections which will require assembly or in monolithic fashion which presents impracticality of movement and the need for careful foundations and site preparation?

Working into the earth

Richard Launder (UK) and Tobjørn Kvasbø (Norway) both chose to work directly into the landscape, with excavations and modification of existing features as the first line of attack. They each chose earth mounds to work on, Tobjørn digging into the top of a clay mound created by pond excavations, while Richard dug directly into the surface of a dam itself.

Tobjørn excavated a large bowl shape. The excavation itself was to serve as a kiln. He lined this with clay, and then coil-built a huge bowl supported on

ridges of clay within this space. The clay-lined excavation and the bowl itself were covered over by a series of arched tubes supported within the bowl itself. These tubes, intended to create a series of chimneys capable of drawing the heat in the desired direction over the surface of the bowl, became the primary visual feature of the work.

A large group of volunteers helped with the on-site clay preparation and the detail of construction. They also placed smaller individual pots within the large bowl prior to forming its arched covering. When the top of this kiln is removed by weathering and erosion at some future date, the internal structure and found vessels should create the impression of an archaeological dig.

The local clay was extended and modified to make it usable. As found, the clay was somewhat sandy but dry and hard. This was moistened and opened up by additions of wet sawdust wedged in by hand. The mix was not precise, but varied from 25 to about 40 per cent sawdust. The clay became usable very quickly with this method, without the sticky mess associatated with simply adding water to hard clay.

After carefully observing the usual

'Large Bowl' by Tobjorn Kvasbo (seen standing centre). The bowl is in an excavation filled with smaller pieces and covered with clay tubes to direct the heat during the wood firing which has just started. Tubes connect to an open mouth fire-box facing in a windward direction.

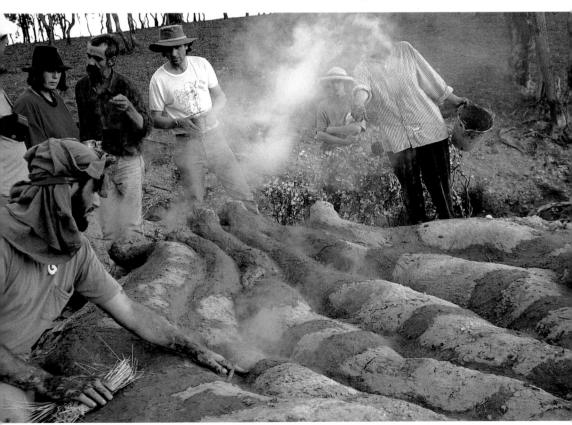

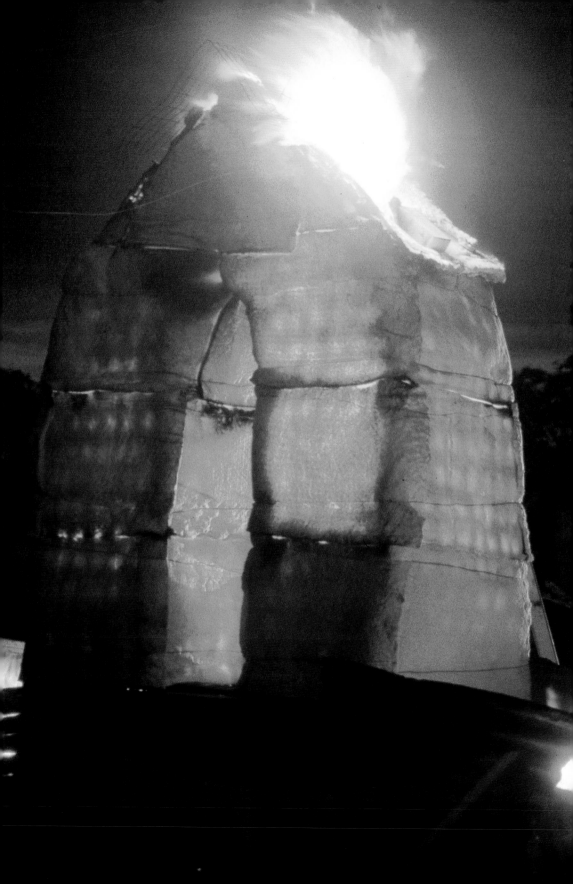

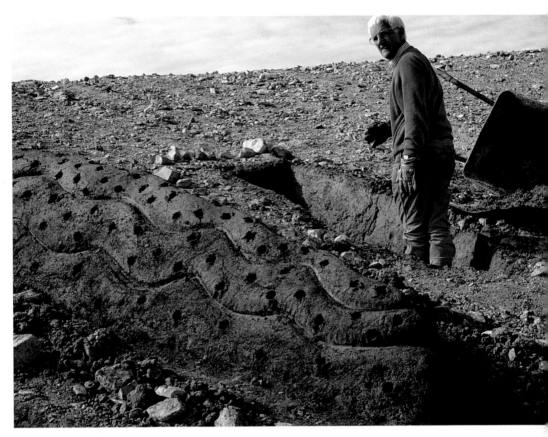

Above
An enthusiastic participant, UK potter Chris Jenkins helps excavate and clad in clay Richard Launder's three-part earth sculpture.

Left
On site firing of 'Archway' by Nina Hole and Jørgen Hansen at Clay Sculpt Gulgong. Ceramic fibre covering proved effective insulation. *Photograph courtesy of Gudrun Klix.*

wind direction, a firebox in the shape of a funnel and a multi-tubed chimney were positioned at opposite ends of the bowl. A small fire gradually warmed and dried the work prior to firing. As luck would have it, of course, the wind direction changed and tended to blow down the flue, the opposite of intentions, making the actual firing quite difficult. It required the

addition of a more vertical chimney to create sufficient 'draw'. An all-night firing produced a red heat glow of sufficient brightness to indicate a reasonable degree of hardness and permanence.

Richard Launder also began with an excavation. His design concept consisted of three elements, one negative, one positive and one two-dimensional shape. The negative element was a boat-shaped void in the dam wall above the water's edge. The soil and rock from this hole was placed next to it in the form of an upturned boat. The third shape was similar, created by stones laid on the surface of the ground. Clay was used to cover each shape and to line the hole to a thickness of about two inches (5 cm).

63

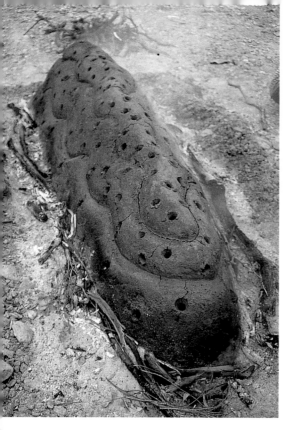

Patterns were also applied. Pegs were made and glazed separately to add colour when inserted into prepared holes on the upturned mound.

The clay in Richard's case was a more sophisticated mix of equal parts: local earthenware clay, a coarse brick clay, sand and sawdust. The pegs were made of a purchased white clay from a nearby quarry, glazed with an alkali frit and copper mix, then fired separately in a small wood-fired kiln for contrast in colour and texture.

The firing was accomplished without a kiln, simply by building small, warming fires around the work, which gradually became roaring bonfires late into the

Detail of Richard Launder's sculpture.

Below
Firing Richard Launder's sculpture.

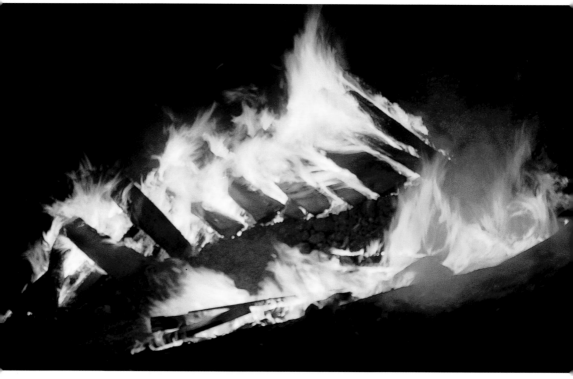

night. The wood slabs from the local sawmill were stacked carefully in a herringbone pattern which created a beautifully considered effect while burning. As part of an evening's perform- ance, the effect was stunning and although on completion there were cracks in evidence, the pieces were nicely marked by flame and relatively durable. During the rainy season, when the pond fills, the boats may appear at the water's edge.

Creating sculptures as kilns

Several participants created vertical sculptural forms. These were mostly coil- built and therefore hollow tubes which could be designed to carry the heat of a flame upwards, thereby acting as a chimney. Wood firing holds a special place in the workings of many potters, and at the Gulgong event, Janet Mansfield (herself an outstanding potter) invited Chester Nealie to advise and supervise the firings at the event. The title of 'Fire Master' was well-earned with a mountain of slab wood used for the many firings which took place during the week.

The sculpture/kilns were formed in a variety of ways but they all had several common requirements. One was that of a firebox constructed into the foundations of the work. A small excavation was the first step. This was lined with brick to contain the fire and support the sculpture above it. One or more openings were provided to facilitate stoking the fire and provide air for combustion.

Another requirement was an easy passage of combustion gases through the work and an exit through the top, effectively creating an updraught kiln out of the piece. Sculpture as an old- fashioned bottle kiln would be one way to describe several of the solutions.

And finally, heat retention and insulation was provided by covering the piece with a ceramic fibre blanket. Alternative (and less expensive) solutions would have been possible through the use of several layers of newspaper and slip or layers of cloth such as hessian, also dipped in slip. An additional volume of heat could have been provided by surrounding the piece itself with a wood cladding before covering the sculpture. To give support to the surface insulation, a layer of wire mesh (chicken-wire) could have been applied first. For even greater support, another layer might have been applied over the insulation material, for instance, paper, cloth or ceramic fibre. These layers could have been stitched together with pieces of wire to provide a sturdy sandwich which would have taken a surprising amount of heat before the interior wire began to weaken.

The works of two partnerships, Gudrun Klix and Richard Tarrant, (Australia) and Nina Hole with Jørgen Hansen (Denmark) provide us with good examples of this firing method. Gundrun's clearly conceived Three Spires were coil- built on brick foundations. To speed things up, an extruder was brought from the studio and bolted to a nearby tree. This looked very amusing but it allowed the rapid production of coils necessary to keep up with the pace of production in the warm weather out of doors. Three large pieces were made in a short space of time with drying winds stiffening lower sections while fresh coils were being continuously added to the top. Plastic covers were regularly needed to slow this process down. The wind direction or direct sun occasionally caused one side to dry more rapidly than the other. Regular spraying with water was necessary to prevent uneven shrinkage, which would have caused the work to crack or lean

disconcertingly in one direction or the other.

The Three Spires by Gudrun Klix were created using a quite heavily grogged clay. The tops were completed and simply removed (and fired separately) to create the opening for flue gases to escape. Each spire was surrounded by long sticks of wood placed vertically to the full height of the work. These were then wrapped to both insulate and give an air-tight covering which helps to create and control the draught. When cloth and slip or paper and slip are used, the insulation is minimal but so is the expense and as the recent spate of articles on paper kilns

Gudrun Klix begins construction of a 'spire'. A brick firebox is constructed as a foundation. Card separates the work from the brick to assist shrinkage without cracking. Photograph courtesy of Gudrun Klix.

testifies, the result is quite effective for low temperature work. Ceramic fibre blanket is quick and effective to use, and since it has excellent insulation qualities, makes higher temperatures possible. If there are drawbacks to its use, they are the considerable cost and the uncomfortable nature of the material in use. The fibres are an irritant and wearing a face mask is recommended when working with it – although when working out of doors, of course, this factor is minimised. It should also be said that with widespread use in recent years, this material, originally developed for the space rocket industry, has actually come down significantly in price.

The actual firing must be done quite slowly, at least in the early stages. Gudrun, assisted by Richard Tarrant, began warming and drying the spires by lighting small twig fires under them

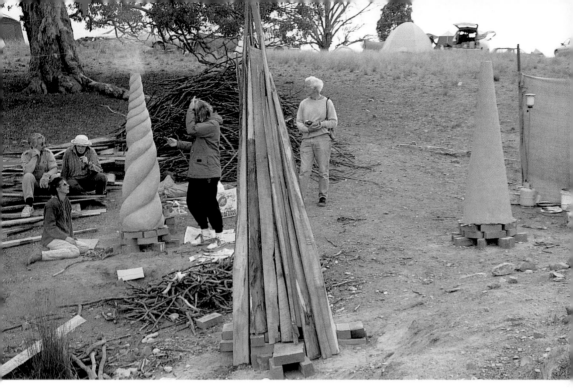

'Three Spires' by Gudron Klix with the assistance of Richard Tarrant. Each spire acts as it own chimney to conduct heat upwards from brick fire-box supports. Drying has begun on the left hand spire. Several layers of wood are then added around the work before cladding in slip-covered cloth or paper. Firings begins under each piece and eventually heat transfer through the walls of the work will ignite the external wood.

before they were even finished. And during the firing, the exterior wood cladding was not ignited immediately, but allowed to warm up to combustion point gradually as the fire under the work transmitted its heat through the walls of the piece itself. The total firing took over 24 hours, and in this case was interrupted by torrential rain. Plastic was wrapped around the kiln and the firing continued the next day. There was surprisingly little damage.

Judging the temperature in an open situation like this can prove problematic. The colour generated by the heat is the most common reference point. A universal red glow suggests the early stages of biscuit temperatures, while stages of red orange to yellow, moving on to white heat suggest increasingly higher temperatures. It is possible, of course, to place a pyrometric probe into a structure and gauge the heat at that location. As well as knowing the ultimate temperature, this will give an indication of the speed at which the heat is rising which is so helpful in the early stages and which can act as an aid to the effectiveness of stoking the fire.

The Arched Form by Nina Hole and Jørgen Hansen was created in an unusual fashion. Individual modules were made and joined together to form a strong lattice-work structure. Individual coils were flattened and curved into horseshoe shapes with legs of uneven length. When stacked in rows, they created an inner and an outer wall, joined at regular intervals along its length. These walls of double thickness had strength without

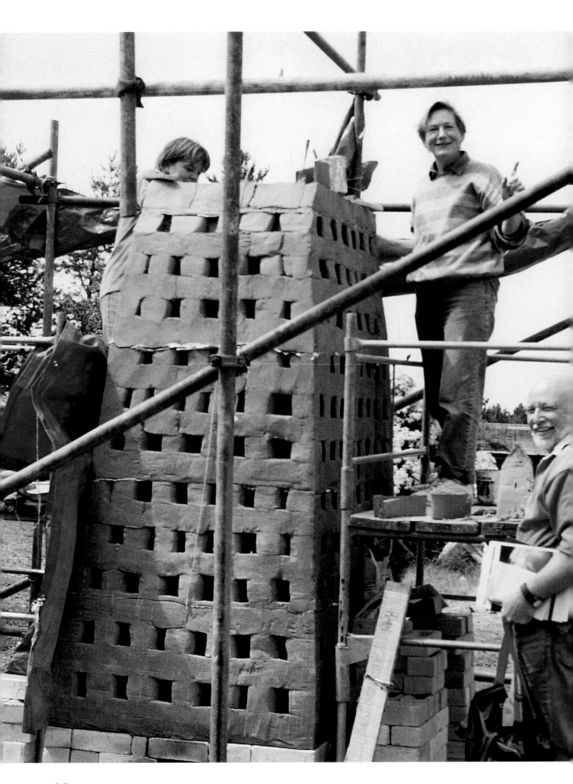

Fired detail of Nina Hole's 'Archway'.
Photograph by Jim Robison.

Detail of construction. Small slabs curved into an extended 'U' shape give an internal and an external wall simultaneously.

Left
Nina Hole pauses to discuss construction of this monumental work with Jim Robison at the Aberystwyth Ceramics Festival in Wales (UK). (PHOTO) Scaffolding and plastic sheets help protect against both drying winds and soaking rains.

undue weight. And as air could pass through the structure, drying was rapid and quite uniform.

The local clay was used – a laborious process that included not only digging, but picking out stones and wedging in dry sawdust to remove excess moisture. The only modification to the clay was the addition of about 20 per cent sawdust. Several days were spent creating balls of prepared clay, wrapping them in plastic and transporting them to the chosen site. Something approaching one tonne of clay was used in all.

The firing was both dramatic and effective. Built upon a brick base which contained two connected fireboxes, and left open at the top, the two legs of the arch were the makings of an updraught kiln. The entire work was covered in ceramic fibre blanket, tied in place with wire. The top had two flaps of blanket which served as dampers and controlled the flow of heat up the legs. Wood fuelled the kiln during a 24-hour cycle and as dawn broke, an enormous raku-style event took place. The ceramic fibre retaining wires were cut, the blanket removed from the glowing structure and sawdust was thrown onto its surface. The natural colour of the red earthenware clay was given enhanced variation by the flame and smoke which resulted.

Chapter Four
Using a factory

For the aspiring large-scale worker, the problems of where to work and how to work can be partially overcome through links with industry. Indeed, just a visit to a factory can completely change the way you look at your own work. The delivery of a ton of clay to the studio might seem like a major event, but when compared to the shuttle of trucks and bulldozers around the clay-mixing machinery at a pipe works, it becomes a drop in the ocean. And *production* – we tend to be so precious about our *handmade* efforts, that to see extrusions of 12 inch diameter (30

Raw materials in quantity greet potters starting work at the Harsa Nesh tile factory Beer-Sheva, Israel.

cm) pipes, 4 feet (120 cm) in length being cut off every few seconds can be a real eye opener. And *firings* – when we can take hours to pack a few pieces in a small chamber and carefully close, or brick up the door, to see the huge rail cars passing through a tunnel kiln with a continuous output at the other end is breathtaking.

For sheer speed, an Israeli tile manufacturer takes some beating. The Negev Ceramics Company has introduced a roller hearth kiln at the end of its conveyer belt production line in the Negev desert, capable of firing raw-glazed floor and wall tiles in just 30 minutes! That is the time *in* the kiln, from the moment they roll in four abreast to be heated to 1150°C until they are cool

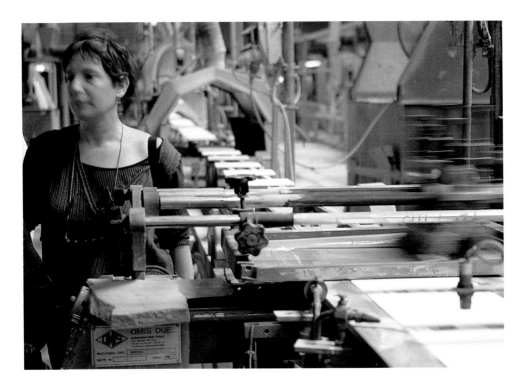

enough to be discharged at the other end onto another conveyer belt taking them to be checked and packed. In fact, this production line stamps out the tiles, coats them with slip, applies silkscreen patterns, glazes and dries them ready to enter the kiln in this same amount of time! I am told that this mixture of Negev desert materials could be fired even faster if the production line could keep up. Admittedly this line starts with virtually dry (5% water) clay which is hot pressed into shape, but even so, the daily output is phenomenal.

Other possible factories include: brick works (often producing several colours and grades of brick clay); and sanitary ware production, which is generally slipcast and provides an optional use of either parts of cast products, or slip used in moulds of your own design. Roof tiles are extruded in some places, and vast tubes of porcelain are turned into

Tile production line at Negev Ceramics. Dry pressed, decorated, glazed and fired in just over an hour.

ceramic insulators by specialist manufacturers. All this is without even mentioning the normal pottery industry, whose ware is small by comparison, but whose technical expertise and production techniques could offer inspiration to the agile mind.

It may seem a daunting prospect to approach a large, imposing office to request access or materials, but don't be put off. You might begin by simply asking if the company has a policy regarding help for struggling artists? Many of the places mentioned have provided artistic residencies or other help to myself and other potters that I know of. A polite request may well open the door to exciting possibilities.

Pipe works

Jerry Caplan (USA) has developed many of his ideas in Pipe Workshops which he runs in factories around the USA. His reputation led him to be invited to offer similar opportunities in the UK and several successful events have been held in Yorkshire through the cooperation of Naylor Brothers Clayware. Their support

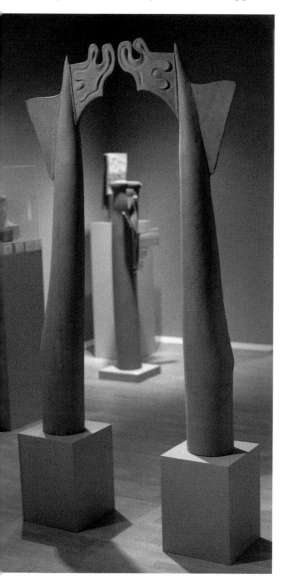

for similar efforts goes back to at least 1978, when I requested and received permission to use their pipes for making sculptures.

Pipes are donated or purchased as fresh extrusions. They are usually quite stiff as the company has no desire to take the time required to dry out any extra water of plasticity. To make them more workable, Jerry advises wrapping the pipe in damp cloth for a day or two before use. The softened clay will distort more easily and permit joints to be readily made. As the clay is heavily grogged, there is little problem with distortion or cracking and large forms can be finished and dried with surprising speed.

Factories dislike disruptions to any assembly line production, so with the exception of organised events, they may prefer the pipes or other materials to be worked upon and fired elsewhere. Pipes are firm enough to be moved to your studio or other sites and can be fired in a normal studio kiln. It should be noted, however, that the clay is a mixture of materials which may include carbon and shale associated with the geological deposits of coal. Pipe manufacturers use the glassy effects of trapped carbon within the clay as a water barrier – a substitute for traditional salt glaze and necessary for effective drainage products. While this also adds strength to the product in their controlled firing cycles, fumes and smoke will be evident during firing and if overfired, some extreme examples of bloating may occur. Temperatures of 1150°C are the maximum for the clays I have used but it is wise to check each material with the manufacturer.

Jerry Caplan is known for many works in pipe clay. 'Arabesque' is an example of large-scale possibilities.

Tiles

Marylyn Dintenfass, from New York, is numbered among the group of 20 artist/potters invited to participate in the second Beer-Sheva Ceramic Biennale in Israel (1993). Working sites included the Negev Ceramics Tile factory which I mentioned above. She was able to pick freshly pressed tiles from the conveyor belt, experiment with applications of slips and brilliantly coloured glazes, reintroduce them at the beginning of the firing sequence and . . . (wait for it – but not long) . . . collect them in a mere half hour!

Within a few days she had developed a range of floor tiles with all the richness of hand woven carpets. Although she had worked with the square format extensively, she had never used tiles before. She counts the work at the factory as a 'pivotal experience'. Using their advanced technology, she was able to combine painting, usually limited to her smaller works, with the modular and more minimalist large-scale architectural work she had created in the past.

M. Angels Domingo Laplana who works under the name of Madola (Spain) has created a truly monumental work in Barcelona. Her traffic roundabout on a hill above the city takes advantage of the engineering abilities of the construction industry (excavation, foundations, plumbing and electricity) and tops it off with a colourful, dramatic utilisation of ceramic tiles. Obviously, this scheme required long-term planning and input from public and private agencies. The point to make here is that Madola made the larger, sculptural tiles in one factory, while commissioning specific outputs of special tiles at two other factories. The combined outputs of artist and factories

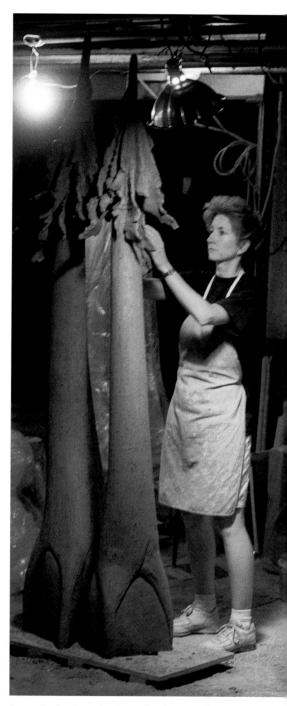

Jerry Caplan's enthusiasm for the use of pipes led him to conduct public workshops at the Mission Clay Company and other locations.

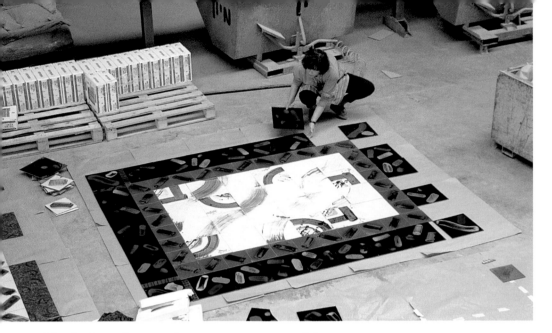

Marylyn Dintenfass at work in Negev
Ceramics Tile Factory.

Below
Detail of Marylyn Dintenfass's tile painting.

Madola's traffic roundabout 'Plaza de la Fuenta Castellana' in Barcelona.

Details of Madola's work which involved three factories as well as her own making of the heaviest tiles.

made possible a much larger public statement than would otherwise be imaginable.

While most artist/potters enjoy the tactile nature of the making process, if you are willing to forego this aspect, ready-made tiles can be purchased already fired and used as they are, or treated as the painting canvas for a larger work. Depending upon the original purpose of the tile (walls or flooring strength), almost any surface can be dramatically enhanced by painted tiles. Plain ones (bisqued only or covered in a single glaze) are probably the easiest to use. Few tiles are fired to stoneware temperatures, so working in the vast and colourful earthenware range is advised. Testing of any material is, of course, essential to success.

Slipcast approaches

Factories that use plaster moulds and vast quantities of liquid clay offer a range of interesting possibilities. The products themselves, produced in multiples, can give rise to rhythm and strength through repetition. And taken out of context, the form and shape of sinks or sanitary ware, for example, develop new meanings when seen as sculpture. Historically, one has only to look at Marcel Du Champ's use of the urinal as a work of art to verify this altered meaning of an everyday object.

Marion Held (USA) used the products of the Harsa Factory to good advantage during the Beer-Sheva Biennale. A floor-

Slipcast toilets at Harsa. Factory shapes and production methods provide inspiration.
Photograph by Jim Robison

Below
Marion Held (USA) used slipcast sanitary ware to fashion a large installation piece.

type toilet became the basis of a large multiple container to hold 'thoughts or drawings' made from smaller pieces of clay and mixed media. Previous work, entitled 'Of Koobi Fora', which focused on bones in caskets, found an extension here. The extensive use of copper oxide created a black surface, full of symbolism, and the additional materials, which included cactus thorns, wire and rubber, generated thoughts far removed from the original white utilitarian product.

Wladyslaw Garnik (Poland) has a studio within a porcelain factory near his Polish home in Wroclaw. His regular use of slip trailing techniques there transferred easily into the Harsa factory. Using a large plaster bat as a working surface, perforated sheets of clay, less than a centimetre thick were created by trailing a web of lines which overlapped into a delicate mesh of interlocked diagonals. Cut into rectangles and curved shapes, the lace-like sheets were joined

Above and below
Wladyslaw Garnik uses slip trailed sheets of clay to create his modular structures.

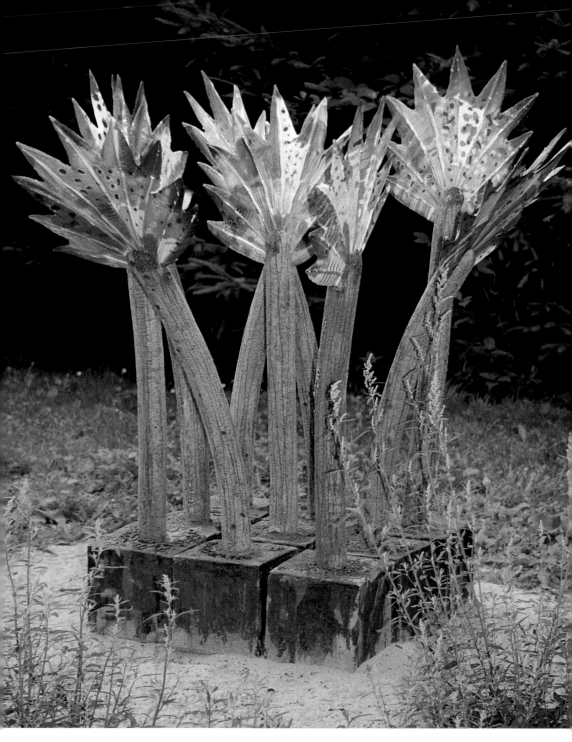

Left
'Sculpture' by Wladyslaw Garnik. Beautifully open lattice work created by slip trailed constructions in porcelain. 6'6" (2 m) tall.

Above
'Petrified Flowers in Blue', cast and constructed pieces, by Elke Huala.

together with additional slip, to form
tubular sleeves from which the whole
work was structured. Small units, about
brick sized, could be made and fired in the
same day. Colour was added to the slip on
occasion, and the trailed lines created a
most delicate texture on close up viewing.
Light and air penetrate the structure,

'Desert Palm and Flowers' by Elke Huala.
Created from slipcast sections.

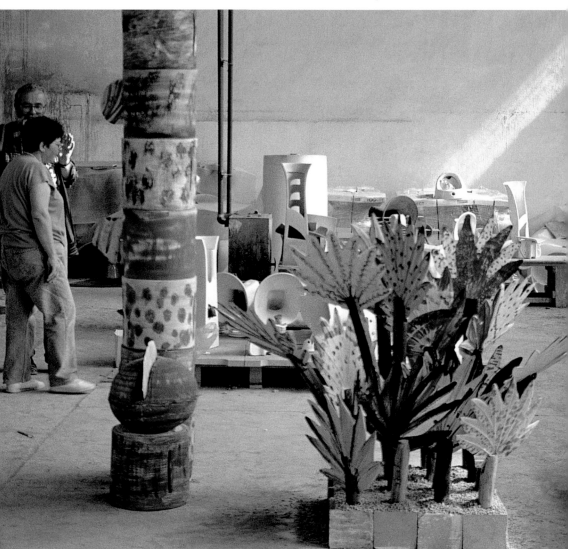

making one aware of enclosed space as an active ingredient within the work. Using araldite epoxy glue to join the units, compositions of impressive dimensions were possible.

Elke Huala (Austria) took advantage of the mouldmaking expertise in the factory to have several moulds made to her own design. The modules of a cylinder and a ribbed leaf made many variations on the theme of desert plants. Entitled, 'Spring in the Negev', these pieces, created in the factory, have inspired new works on her return home to her studio in Austria. 'Versteinde Blumer Vertont in Blau' (Petrified Flowers Tinted in Blue) also speak of the influence that a factory experience can have on one's studio practice.

Backs modelled from large slipcast sheets of clay by Irit Mosen.

Irit Mosen (Israel) used the liberal quantities of slip available to cast large slabs which became relief sculptures relating simultaneously to figure and landscape. A simple wooden frame was placed upon a plaster slab. This was filled with slip which was allowed to stiffen. Then Irit carefully lifted the edge and pushed the forms up from underneath. Wads of paper supported the forms and oxide colourants were applied to the surface. They were dried slowly to avoid cracking and fired along with sinks and toilets in the large factory kilns.

When using materials in an unfamiliar way, there is always a period of adjustment. Slip, for example, behaves differently to the usual slab or modelled clay. I found, when attempting to join sections of still pliable castings, that the material would suddenly remember its liquid origins and attempt to revert to a fluid state. There is as Irit put it, 'a long process of listening to the material, trying to find out where it would lead me'. After that, she says, 'I spoke and the material listened'.

Brick works

Clay is such a commonly found material that brick works abound. In some regions of England, farmers at one time used the winter months to produce such building materials as might be needed for the next summer's projects. Although the numbers are reduced and concentrated among fewer large-scale manufacturers, the likelihood is that one is within a reasonable striking distance and most I would expect to be willing to part with pre-formed, unfired items which only have a minimal value to them. Several artists and organisations have gone so far as to make these sorts of contacts a

Gwen Heeney carves into the surfaces of bricks before firing and assembly on site.

regular source of materials and inspiration. Where demand is great, the company can be expected to make a charge for materials although when compared to the purchase of prepared pottery clay, this is a comparatively insignificant sum.

Wakefield-based Public Arts, one of the regional companies dedicated to

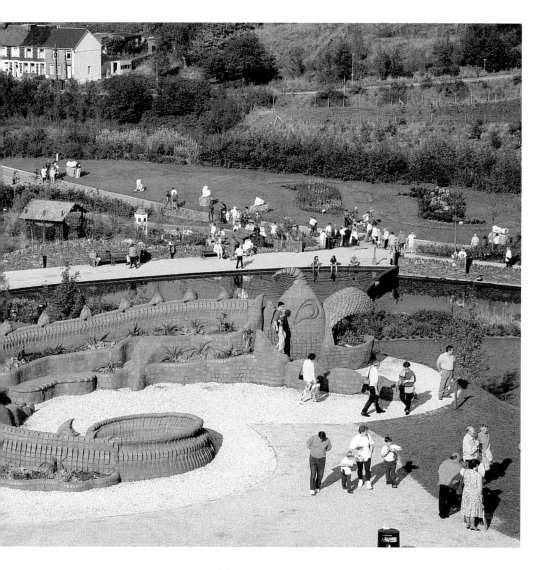

promoting art commissions in public places, has had considerable success in arranging sponsorship of projects through the local Ibstock Brick Company. Artists have been given work space in the 'Specials Department', access to the range of coloured brick clays and technical assistance as required.

Julia Barton (UK) has undertaken commissions in Featherstone, West Yorkshire, for walls next to busy roads and parks open to the public. Substantial areas of the community have been revitalised as the result of these collaborative efforts. Designs are created with the variety of coloured bricks available. Freshly-made bricks are arranged accordingly, relief surfaces are carved into the leatherhard clay, slips and stains applied as desired, and then allowed to dry before firing. The bricks are individually numbered with oxides and a careful pattern made for reassembly and installation purposes.

Chapter Five
Group approaches with community and educational potential

Few projects have the capacity to excite pupils to such an extent as a clay mural or garden sculpture. Often within a school, there is a blank wall or a protected inner courtyard where the combined efforts of teacher and class can hold imaginative sway. The range of subjects for such an undertaking is almost endless if you consider the school curriculum, and there is considerable potential for children to feel a part of something special within the school.

Clay itself has the capacity to stimulate involvement, and given the versatility of the material and with its ability to be recycled, it need not be considered prohibitively expensive. As the objective of this book is to look at rather ambitious work, I won't deal with everyday projects but instead look at some adventurous alternatives.

Events and exercises

When reading an issue of *Ceramics Monthly*, I came across a rather tongue-in-cheek mention of a California *World* Olympic event using clay. Ignoring the

Youngsters compete to create the tallest slab structure at the 'Clay Olympics' at Leeds University College, Bretton Hall.

implication that California *was* the world, I found the prospect of Giant Pots, a competition using clay in various guises, most intriguing. Adults have their potters' events, often massive occasions where professionals are stretched to their limits before an appreciative audience, so why shouldn't youngsters or other groups enjoy a participation event?

When discussed with my university students at Bretton Hall College, they too, were stimulated by the possibilities, and once excitement is generated within the classroom, it tends to take on a momentum of its own. Thus our very own Clay Olympics was born. Designed to encourage teachers to use clay, stimulate team spirit, and generate the practice of ceramic skills, the following were some of the suggested events put to neighbouring schools.

Using pre-measured amounts of clay and a limited time scale, complete the following:

1. Roll the longest unbroken clay coil possible (use a team of two people).
2. Create the tallest coil pot possible (use a team of three people).
3. Create the largest clay slab possible (use a team of two people).
4. Create the highest slab-built structure/sculpture possible (using a team of three people).
5. Make and compete with clay conkers (bisque fired only – stoneware temperatures are cheating!), be sure to bring gloves and goggles to this one!
6. Throwing the tallest pot possible (or widest, thinnest, greatest number etc.).
7. Throwing with a difference (no use of hands for instance, or for fun, a distance event using a brick!).
8. Ambitious modelling: within 10 minutes, make Cinderella'a coach and six horses, ready to take her to the ball (team of three people).

Teams were created within the various schools, colleges and adult education classes where they practised their skills. T-shirts were printed, muscles were flexed and on the day, they all came together, divided up into three age groups and, supervised by judges with whistles and tape measures, pitted their skills against each other and the clock. Professional demonstrations, educational videos, and the ice cream van all helped to make it a memorable occasion.

Group projects

Using themes or ideas appropriate to the situation, a group of individuals can be the focus of a larger project than is normally undertaken by the individual potter. Not only schools but community groups or ceramic forums can be the source of tremendous energy and enthusiasm. The three projects illustrated here indicate some of the possibilities.

1. Community project

This sculpture was the outcome of a Public Arts competition which aimed to improve the environment of a local housing estate. It involved the residents in the regeneration of waste ground into a cared-for garden. Funding was provided by various grants and European Community monies.

The sculpture incorporated press-moulded images which came from the homes and the environment itself. Initially, a trailer loaded with clay, myself and a helper arrived on the scene to begin taking clay impressions of footpaths, trees, fences and brickwork. With local

encouraged help, moulds were taken of many personal artifacts, including important items such as the winning darts match trophy and a crucifix. When the moulds had been edited and selected, the sculpture itself was then created in the studio, with visitations by participants. In this case, the bulk of the work was done by the artist, but there is a sense of ownership and civic pride generated by the involvement. The installation, formal unveiling and celebratory drinks on the lawn when

Left
'Willow Gardens' community sculpture by Jim Robison. Dozens of clay press moulds were made on site. The unveiling had a special sense of occasion.

Right
Detail of community sculpture. Residents contributed images which included a crucifix, flowers and a toy hand grenade.

Below
Modules of columns under construction.

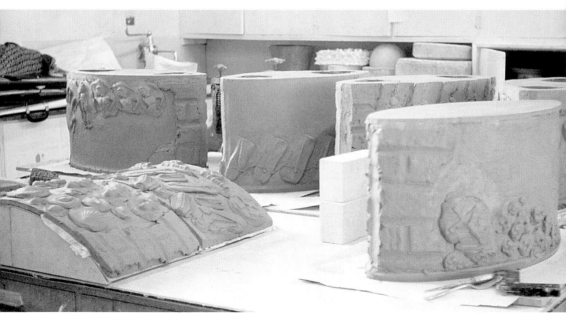

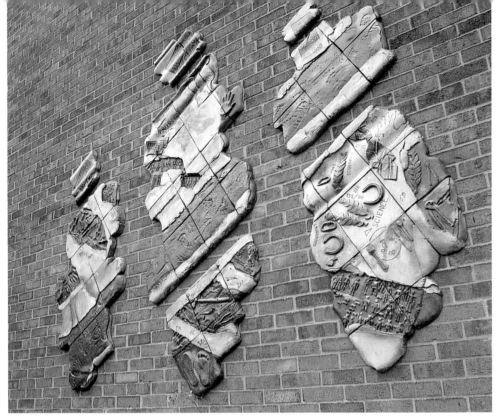

completed were probably as near to an art gallery 'opening' as many of the residents will ever attend. An experience pleasantly remembered.

2. Artist residency

Schools, hospitals, and other semi-public locations may offer the chance to be involved on a substantial project for an extended period of time. Funding can be found through a variety of sources, including parent groups, regional art associations and community trusts. The Northern Potters Association of Great Britain, for example, has a special fund for educational work which offers a daily rate of pay for approved applicants. Sometimes these residencies are advertised, but it is possible for enthusiastic artists/potters or teachers to initiate such projects themselves.

The project illustrated included a

Holmfirth High School 'Entrance Sculpture' by Jim Robison was created with pupil help over a 10-week period.

Right, above
Wooden frames help regulate tile size. Moulds of Star Wars toys helped generate crowd scenes.

Right, below
Full-scale drawings helped with planning in the school hall. Clay on the floor did not please the caretaker however.

funding partnership between the school and the Regional Arts Association. Materials, firings and space to work were included in the school's provision while a number of day's pay (at a modest rate) were negotiated for the project and covered by the Arts Association.

Designs centred around discussions with pupils about the nature of school and its various subjects. The busy

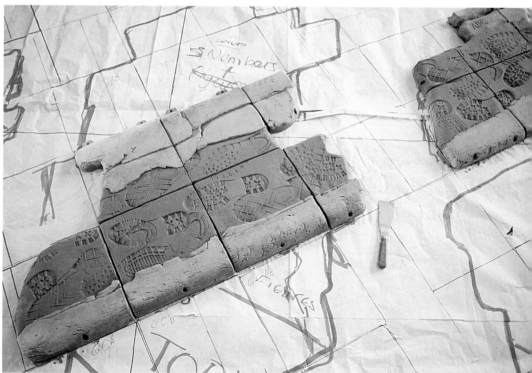

Detail of tiles. Attached with rust-proof screws, mounting holes were filled with stained automotive body filler.

comings and goings were represented by a diagonal path with the impressions of many feet. This was made from a clay slab which crossed the entire length of the art room. Groups of people were represented by the use of press-moulded figures (a good use for the old Star Wars collection) turned out in an assembly line production. Plastic lettering stencils were used to create alphabets and details were picked out in white slip and an iron/manganese wash. The pupils put their minds to finding images and words which could depict the many aspects of school life, not forgetting school dinners,

and the whole was assembled in the school hall. This of course delighted the school caretaker, and it had to be moved onto the stage between working periods, but we managed to complete the work with a few additional evenings' effort.

Several important points to consider:

Treat the whole project as a learning event with flexibility in mind. For example, computer images were used as part of the design stage, from which a full-scale drawing was created.

As often happens in a hurried situation, the first kiln firing took place before pieces were dry, with predictable results. The children, as well as myself, had to swallow hard, then simply get down to doing it all again . . . (better this time).

The sections of the mural were made in wooden frames to give a degree of control over the size of each piece. By having several frames, each identical and the predetermined size of a kiln shelf, individual pieces could be worked upon, knowing that they would all fit together in the end.

Installation should be considered at the beginning, so that provision is incorporated in the making. On this project, due in part to the limited time and budget available, holes were simply made through the tiles and countersunk into the surface with the handle of a wooden spoon. Long, rust-proof screws hold each tile in place on a brick wall. The screw heads are covered with a resin-type automotive filler, stained with oxides for a near match. Other options would have been to hide the screws under glued on ceramic fragments, or disguise mountings along the edges.

The type of wall, its location, strength and surface texture will have an effect

upon the design and mounting. A smooth internal wall and a mural composed of relatively thin tiles could simply be attached with readily available tile adhesive. An external, concrete-rendered wall could have tiles set into a cement-based mortar. Heavily textured brick or stone will require a bold design and considerable care in mounting. The area could be rendered smooth to start with, or a framed mounting board attached to the wall to carry the work. For group work which may need to be removed in the future, this 'framed picture' approach is probably best.

'Sunflower Shower' by Joan Campbell (Australia). A functioning shower group, created with the help of many hands during Janet Mansfield's event Clay Sculpt Gulgong.

Left
Gwen Heeney's helpers carve soft bricks for a panel based on Welsh Mythology.

3. Ceramics festivals

Every summer, potters' organisations around the globe offer opportunities for attendance at a whole range of events. Many are purely observational in nature, some have kiln firings with a bit of 'hands on' making and a few make the effort to organise participation in a sizeable way.

International gatherings such as the

Aberystwyth (mid-Wales) Bi-annual event are examples of the latter. On one occasion, the Welsh effort resulted in an exciting mural with individual elements contributed by participants and demonstrators alike. Recently, Gwen Heeney mounted an ambitious effort with raw bricks, while ambitious kiln building and firings have added to the feeling of occasion.

Janet Mansfield's Clay Sculpt Gulgong (Australia) is another example of such an event. Clay Sculpt set out to prove that if big is good, then bigger is even better and prove this it did. By sending invitations to some 20 of the world's leading potter/sculptors to come and develop their ideas on her 450 acre ranch, she created a unique opportunity for the some 450 participants to observe, contribute and learn from the experience.

A number of permanent, impressive sculptures were created at this event, several of which feature in this book. However, a number were more temporary, like the carefully composed night-time firings of sheep droppings. These were combined with the sounds of drums and Aboriginal digeridoos to generate the most dramatic of events. And beyond all this there was also a sense of a sharing on a vast, world-sized stage. People from many cultures were drawn by an enthusiasm for ceramics – truly 'Large Scale Ceramics'!

Chapter Six
Commissions

Starting out

As with any job or occupation, the first hurdle is that initial employment experience. Everyone is happy to employ a pro – but how do you become one if only professionals are employed? It's the Catch 22 situation where you are after the job where 'experience is required' and you wonder how *does* one get on the ladder to *get* this ingredient?

The first thing to say that *success is not a destination, but a journey* that is undertaken. You need to create situations for yourself to stimulate growth into the person, artist/maker that you want to be. This will probably begin with education and contacts leading to association with professionals. You may be fortunate enough to find short- or long-term apprenticeships. You certainly will be able to obtain helpful advice from potters' and arts organisations around the country. And once you have begun down the road of making, it is largely a matter of your own intent that determines where you end up.

A few pointers:

1. Prepare yourself for larger works by occasionally stretching yourself beyond what you've done before. Make big pieces, even if they don't readily sell. Whatever else, it will make your normal scale easier to achieve.
2. Experience is the basis of confidence. Don't try to run before you can walk, but push yourself until you have a body of work together that you feel happy with and can talk about.
3. Seek opportunities to exhibit and accept small commissions that come along. It all helps to build up a track record you can use to promote your work.
4. See yourself as a professional and get to know others in the field. You can start by joining a potters organisation, attending events, taking part in exhibitions, perhaps offering to help and generally becoming involved in regional activities. This can lead to national and even international involvement.
5. Publicity helps. Prepare a C.V. and colour photographs of your work to show to gallery owners, architects, other potters or anyone who might be interested in what you do. The advent of the colour photocopy makes the preparation of several duplicate documents a simple thing to do. A printed postcard, with your name and phone number, can result in unexpected benefits. My first postcard, of pieces photographed in the garden and given away at a potters' festival, resulted in a phone call and subsequent sculpture commission to celebrate the City of Cambridge.
6. Try to have work published. Photographs are often accepted for publication in specialist magazines. Other publications such as architectural journals, *House and Gardens*, and newspapers should not be overlooked. The local paper could

just spark off a neighbour who wants an interesting sculpture in the garden.

7. Seek out opportunities. Subscribe to the specialist literature where events, lectures, specialist classes, exhibitions, jobs and commissions are advertised. Make yourself known by requesting information of regional arts organisations, Crafts Councils, Public Arts and local interest groups. The monthly *Artists Newsletter* (in the UK) has several full pages listing commissions and other opportunities. Check your area for similar publications. Send for details and apply for any that seem within your ability.

8. Don't assume that more experienced heads will automatically have the advantage and don't give up if rejected. Fresh imagery and enthusiasm count for an awful lot and persistence is one of the most important attributes you can develop.

When asked the secret of success, I sometimes jokingly say that it is 'longevity', because it takes so long to arrive. The fact that my family and I have lived and worked in the same place for over 20 years has meant that my workplace has gradually taken on a shape to our liking and to others' admiration. And when people say to me, 'aren't you lucky to have a place like this?' I'm very tempted to repeat a quote I read which goes, 'funny thing, but you know, the harder I work, the luckier I get!'

As Peter Callas, who throws and fires for Peter Voulkos these days, said in response to the same question about success:

> You must develop credibility . . . find the opportunity to do something. (On a friend's property, for example.) In my case, I had to go through a series of works to give me confidence to go on to do other works and, eventually to apply to do large-scale public works. It's a matter of building up a sense of confidence within yourself and building up a credibility through a portfolio. No matter what you do, it's a matter of hard work. Believe in your work and yourself.

Working to commission

The clients

Often the first working relationships are established among **friends or relatives**. This is a good way to start as these people will be supportive and encouraging, and rather less critical if things go a little wrong and time scales aren't met. It has drawbacks of course, as you seldom feel able to charge the full value of the work and perhaps later on, you will look back on early works distributed among family members with some embarrassment.

Individuals who have seen your work, or have heard about your workshop/studio, form another category of clients. It is always nice to be asked to make things for people you do not know. It suggests that the work is admired in its own right, and it's not just friends being supportive of you, the person. There can

Right, above
'Three Faces of West Yorkshire' by Jim Robison. Entrance feature for Calum Woods Park, Dewsbury (7′ h x 12′ w).

Right, below
Tiles are bedded into cement for strength. Gaps were filled with silicon mastic. Installation also included construction of the pyramid in stone and cement.

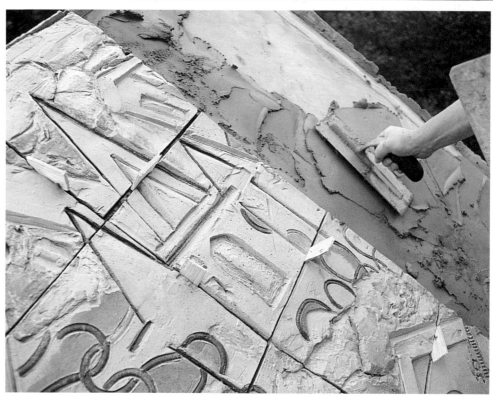

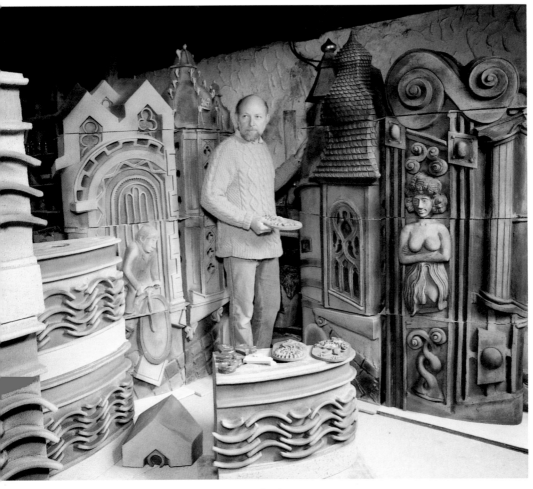

'Cambridge/Heidelberg' by Jim Robison. Trial assembly of the 40 sections that make up the work.

be problems in early days, while a work style is evolving, as great discrepancies may exist between your views (what you wish to make) and what is being sought. You will just have to decide what is worth doing both aesthetically and financially. You also need to establish a clear idea of what the person has in mind and what sort of budget is proposed. Initial enquiries usually are probing to have you reveal the costs of such projects and it is easy to frighten away potential clients if bald figures are announced. A range of possibilities is easier to accept and opens avenues for discussion. Enthusiasm will help sell the project, but remember that the bills have to be paid too.

Business clients provide the most frequent commissions for relief sculptures and larger works. They are concerned about public image, corporate identity, and are among the most likely to be persuaded by the uniqueness that purchase of a work of art can bring. They also have large walls and spaces in need of enlivening! New buildings and

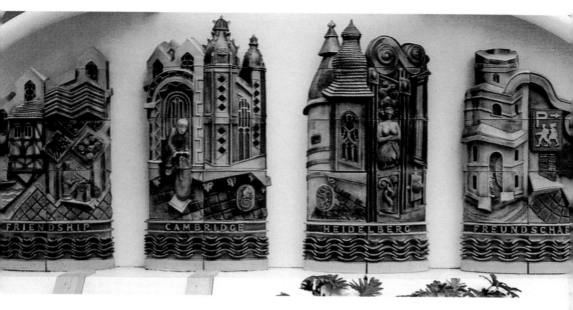

FRIENDSHIP · CAMBRIDGE · HEIDELBERG · FREUNDSCHAF

'Cambridge/Heidelberg' by Jim Robison. Twin Town sculpture (8' x 24'), commissioned by the Grosvenor Estates for the Grafton Shopping Centre in Cambridge.

extensions have budgets which may include some expenditure for 'enhancements' and within overall budgets, your costs will compare favourably with plastering and plumbing.

While happy to drive a hard bargain, I have found businessmen to be reasonably generous once committed to a project. Engineering advice and installation can often be handled as part of the building work, using consultants and skilled labour already on site. Expenses for travel are easier to obtain. (I was once flown to Germany so that photographs and drawings could be made in Heidelberg, the subject of a 'Twin Town' sculpture to be erected in Cambridge.) And in larger firms there may be the advantage of a publicity department with ample funds to photograph and publicise your work – wonderful material for promotional purposes.

Governmental and other agencies are involved with improvements and renewals of public sites. Public buildings, such as libraries, theatres, art galleries, and hospitals are regularly recipients of

artworks. Open spaces such as city squares, parks and gardens, are possible venues as are urban and housing renewal schemes.

Local government, with its planning officers, may fund or partially fund works with help from the Arts Council, Crafts Council, private businesses and philanthropic sponsorship. There are coordinating agencies such as Public Arts and regional bodies which help with planning, designing the artist's brief, recruiting appropriate artists, and coordinating the input from all the various parties involved. Indeed, in my own region of West Yorkshire, Public Arts has stimulated and overseen the production of artworks for many sites, including park features, 'Waymarkers' along miles of Kirklees footpaths, the Huddersfield public library and the Lawrence Batley Theatre. Throughout

Agreeing a budget

Commissions which are advertised in the press and circulated among arts agencies usually have a figure attached to them. This will have been arrived at through considered advice . . . (one hopes) or it may simply state the amount available. Either way, it is seldom a generous amount for the job and is worth questioning. One recent city centre offering (relief sculpture, to include installation) at £10,000 sounded fantastic until confronted by an unsightly wall some 7 metres high by 40 metres long! To make beautiful a partly rendered and graffiti covered wall of this scale could take up this amount in scaffolding and preparation alone. Obviously, there needs to be some room for negotiation!

Even where the amount is not stipulated in advance, the customer will usually have some figure in mind and you must have some idea of what to charge. Time, materials and overheads (plus a bit for contingencies or profit) are the usual determinants. And unless there is some particular reason for thinking otherwise, size counts! Cost per square metre may not be a comfortable notion yet it is a useful measure by which to anticipate expenditure.

When discussing the price of artwork for the Yorkshire Purchasing Organisation foyer, we discovered the anticipated price per square foot took the project well beyond budget if the entire wall was to be covered. The solution was to design four smaller panels, each distinctive, but with related images that linked together. This set up design constraints which, far from being a problem, actually contributed to the success of the final work.

A large wall, in desperate need of attention. This will require major preparation work before artwork can be considered.

the county, town planning and rejuvenation efforts frequently apply principles of landscape design, embracing artworks, to the problems they face. Check in your area to see if similar projects are a possibility.

Other factors

Among other factors to consider: Does the site or wall need cleaning, painting, plastering, or other preparation? Do foundations need putting in, a plinth made or paving installed? Will you be responsible for installation? If so, will you need engineering advice, special tools, scaffolding, assistance? Who will tidy and finish off the surrounding area? Will the lighting be adequate and if not, should wiring be installed before the work is in position?

These and a hundred other questions come to mind. The essential thing is to know what *you* will have to provide, and the costs.

Pricing

It will be impossible in these few pages to provide all the answers to this vexing question but a few suggestions to avoid underpricing may be in order.

Don't undervalue yourself. Skilled work should be reasonably paid, even though this may add up to more than expected.

Try to estimate the hours, or days of work involved at a rate you are prepared to work for. Then keep a record of hours actually worked. Even notes on a calendar will do. It may be very sobering but it will help you to be more realistic next time.

Cost your materials. Be generous with clay. Unless you use porcelain or 'T' material, it will probably be the least of your expenses. Tonne purchases will cost much less than individual bags and may leave you with a pleasant surplus.

Overheads include rent, rates, heat, light, phone, insurance, postage, stationery, travel, wear and tear plus depreciation of equipment and a few other things. You really need to add up a years' expenses and divide by 12 to give you a monthly running cost. Studio time set against commissions needs to be added to labour and material.

Sometimes it is worth doing a thing for less than it should cost. A loss-leader may lead to other work, or provide other kinds of satisfaction. Just don't kid yourself and be prepared to do the additional things necessary to pay the bills.

Contract

It is important to obtain written commitment to any significant project. This need not be complicated but should spell out the areas of agreement between the parties. It will generally include a description of the work to be undertaken, specify agreed amount(s) to be paid and may specify an agreed timetable for completion. Complicated or extensive projects may require legal advice and if in doubt, seek more information.

Payment

Among friends or where small amounts are concerned, you may simply deliver and be paid. If substantial outlays for materials are required, you can ask for an initial payment to get started.

On larger and extensive projects, it is usual to expect a design fee to be paid on completion of agreed drawings and models of the proposed artwork. This is to be paid whether or not the actual work is then commissioned and produced. This offers some protection against hours spent if the client decides not to proceed due to costs or some other reason.

Once commissioned, several payments

may be preferable to a single final settlement. One possibility is to divide the total bill into several parts. An 'up front' starting up sum or 'tranche', another at a midway point, and another on delivery. I usually invite the clients to the studio to inspect work in progress before submitting an account at the midway point. Studio visits and discussions about the artwork go some way towards building good working relationships. They promote respect for your abilities, greater involvement in the project and a certain pride in ownership.

Installation

I try to regard the installation of sculptures and reliefs as separate from the making. Where possible (and necessary) the client is asked to take on some responsibility for this. This is likely to be the case where external murals are part of the building's brickwork or foundations to support the work are required. This may not be appropriate for all pieces – perhaps the installation is of a delicate nature and too precious to hand over to someone else, or it may be just easier and less expensive to do it oneself, rather than explain how it needs to be done. Whatever you decide, installation is something which must be discussed at an early stage of the project and invoiced according to involvement and material costs incurred.

Chapter Seven
Technical notes

Before you start, location influences

Large pots and sculptures placed outside may need to withstand physical abuse, soaking rain and freezing temperatures. Raku ware and porous earthenware can be very fragile and therefore they are more suitable for interior works. Also, being porous, they will be vulnerable to frost damage, so any outdoor locations will need to be in sunny climes. Industrial clays used for pipes, exterior tiles and bricks are designed to be vitrified at lower temperatures, glazed to be waterproof or have pores of a size which will allow free passage of water with minimum damage. The high fired and vitrified clays, such as stoneware and porcelain, will be altogether stronger, frost resistant and therefore are most suitable for outdoor situations.

Clay bodies

The body to be used in any project will be determined by many factors. The size and thickness of individual pieces will be very significant. Generally, the smaller the piece and thinner the cross-section, the finer the clay that may be used. Larger pieces need to be opened up with sand or grog or both. This will reduce shrinkage and tendencies to warp or crack.

Clay body examples

A good example of a general stoneware clay for large-scale work is the one used by Tova Beck-Friedman. It consists of:

40% Fireclay
10% Rough grog
15% Medium grog
35% Ball clay

A smoother clay suitable for throwing, extrusions and handbuilding as used by David and Margaret Frith is:

67.74% Hy-plas ball clay
20.16% China clay
8.06% Sand
4.03% Grog (20s to dust)

Additions to clay

Amounts of *grog* may vary considerably, from 10 per cent up to perhaps 60 per cent in very solid works. In addition to grog, other materials, such as *sawdust* or *paper pulp* may also be used to decrease density and weight; thus allowing steam to escape more easily during firing. There are several fibres which may be used to strengthen clay bodies and reduce cracking tendencies. Paper pulp, particularly one with a high rag content, will give great dried strength. *Glass fibre* matt or strands worked into slip will remain flexible and resist cracking. (Although it does melt at around 1200°C.) Colin Pearson wedges chopped *nylon fibres* into plastic clay to gain wet

clay strength. It helps hold the large elaborate handles together during rapid assembly that may include drying blasts from a blow torch. (It is supplied by the West Yorkshire firm Pennine Fibre Industries, of Denholme, Bradford.) The ½ inch (12 mm) strands work well in additions of around 2 to 10 per cent. Paper pulp can be added at around 25 per cent.

David Frith has considerable success extruding large tiles and other shapes. To increase the strength and workability of the clay, he may add a small amount of the industrial clay conditioner (Tilex-

David Frith has developed clay bodies suitable for extruding large tiles and tubes. To help the extrusion, the board is lightly sanded and a paper roll is gently pulled along as clay comes out.

Additive A) to the mix. This 'clay conditioner' Calcium Lignosulphonate, a soluble form of Lignin, is derived from spruce wood. It is available in bulk form from: Lignotech UK Ltd., Clayton Road, Birchwood, Warrington, Cheshire, WA3 6QQ. Although available in bulk, you only need to use very small amounts. Only ½ pint added to 3 cwt of clay is said not only to increase the workability of a ball/fire clay body, but will also:

1. Increase green strength by 21.2%.
2. Reduce required moisture content of clay by 9%.
3. Increase extruder efficiency by 27.9%.

Its only drawback appears to be that once dry, the hardness of the clay makes it very difficult to reclaim scraps or unfired pieces.

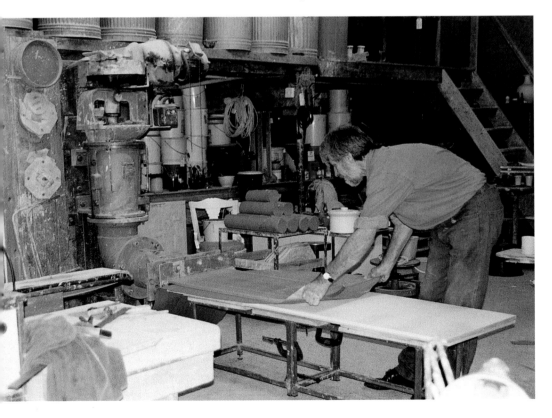

Colour and texture

The list of possible variations is nearly endless. *Oxides* and *body stains* are used extensively. Clay bodies do take a lot of colour though and it is expensive. For example, Shaws of Darwen, who make architectural terracotta showed me a sample of a special clay mix where the body was only £100 per tonne, but the colour addition was £650 per tonne. This gave a grand total of £750. And you don't get many bricks per tonne!

Slips, on the other hand, may be coloured easily and since you are not colouring the entire clay body, will be much less expensive. Two to 12 per cent of a given stain or oxide should be sufficient. They can be painted or sprayed on. Sands, grogs and other materials can be mixed in without fear of upsetting the strength of the finished object. Combustible materials and various fluxes will leave craters, melt and react with surface glazes.

Glazes provide great variety in colour and texture. They will also use oxides and stains most efficiently. Although I tend to have a preference for matt or satin surfaces, smooth textures and transparent glazes enrich colours and also clean most easily – an important factor in some instances.

Detail of 'Landscape Vase' by Jim Robison. Coarse crank clay is impressed with cloth. Porcelain slip is brushed, combed and trailed on for contrasting texture and colour. Four glazes including ash with copper oxide and a translucent tin glaze are then applied by spraying. Dark iron specks and blushes of copper red are encouraged by reduction firing in a gas kiln. *Photograph by Nick Broomhead*

Points to consider

When embarking on large-scale projects, there are a number of points to consider:

Making

1. When building large pieces or laying up relief sculptures for walls, the working surface (table, floor or boards) needs to be separated from the work. A layer of sand, cardboard, heavy paper or newsprint will allow the movement necessary for shrinkage without cracking.

2. After several frustrating attempts to remove clay tiles stuck to tables or plywood, I now use a tar impregnated builders paper, intended for use behind wood cladding, to cover tables or boards first. This also prevents drying from below and warped tables or supporting boards due to water absorption. A long knife can be used

to cut through the paper when the sections are ready to be separated for drying and the paper can then be removed from the back. *Note*: This approach is only necessary for lengthy projects. In some cases, it may actually be an advantage to work on an absorbing surface, e.g. to hasten drying from both sides.

3. Extended working periods will require wrapping pieces carefully in plastic sheeting. Use thin plastic that will cling to the surface of the clay. Heavy plastic will leave air gaps around the piece and allow water to evaporate.

4. First, place damp layers of paper or cloth over the work to absorb the evaporating moisture and keep it next to the clay surface. Otherwise, airborne water will condense on the plastic only to run down and soften the parts you are trying to stiffen up.

5. When large slab pieces are to be constructed, make all the slabs at once, so that they will stiffen at the same rate and have the same moisture content when they are joined together. It is surprising to see how stiff two pieces of clay can be and still join successfully, but a soft and hard slab are likely to crack at the joint and will certainly warp as they shrink unevenly during drying.

Extruding tiles

1. The firm of Craig Bragdy Design, using advice from David Frith, has been extruding tiles up to 1,800 mm long. A recent commission for Hong Kong used tiles 600 mm long and 400 to 500 mm wide.

2. Warping and cracking are age old and intrinsic problems with ceramics. These effects can generally be countered by looking after the tiles in a sensible manner. The tiles can be weighted and turned. This helps the moisture to come out of the tiles evenly.

Drying

Even, uniform drying is essential to avoid distortions and disturbing cracks. It helps to observe the following:

1. A slow, steady contraction will reduce stresses. This is especially important if

This 10 inch (26 cm) diameter square tube is suitable for mass production of box shapes or sculptural applications.

a dense clay is used. Cover work but allow some air to circulate.

2. Tall pieces must be rotated frequently to avoid leaning towards heat or draughts. A radiator or even sun through a window will rapidly create a leaning Tower of Pisa out of your project. Rotating the work *after* the lean is too late, as the whole piece just seems to get shorter.

3. Drying the underside of thick tiles or other work can be helped by using slatted shelves. Several uniform strips of timber can be laid on a table to dry work on. I keep a bundle of 1¼ inch (3 cm) square pieces about 4 foot (1.3 m) long for this purpose. Drying from the top only will give curled up edges.

4. Separate sections of murals as soon as they are dry enough to be handled, taking care not to bend or distort them. Edges of relief work must not dry ahead of the centre sections or uneven shrinkage will create large gaps in your finished work.

Glazing

There may be some variation in normal glazing procedures for larger works. Items may be too large to dip in even the largest bucket (and could it be lifted anyway?). Brush on glazes are one solution. I find that a spray gun is an effective way to cover large areas. Some points to note are:

1. Sculptural pieces may only need an oxide wash to pick up textures and emphasise the form.

2. Given the difficulty in handling heavy items, and the expense of kiln firings, it might be preferable to raw glaze and once fire the work. It means only picking it up only *once* – but *very carefully*.

3. Bisque firing does make things easier to handle during glazing and a high temperature bisque (1170° to 1220°C) will develop the structural strength of the clay. Low temperature, colourful glazes and lustres may be then applied to very strong items and there will generally be fewer problems of glaze crazing. Craig Bragby Designs takes this approach with their vast tile murals and swimming pools.

4. Spray glazing takes some practice. Several thin coats will cover better than one thick one. Take your time and avoid runs.

5. Spray glazing creates a lot of dust. Do wear the appropriate protective mask. I spray outside, weather permitting, if items are too large for the spray booth. Be prepared to mop and sponge down the studio when finished.

6. David Frith pours and dips even his largest ware. He uses large pans of glaze, dipping the top half and pouring the bottom half while rotating the work on a banding wheel. The bases of bisque-fired pots are covered with wax resist and the banding wheel is supported on sticks over the glaze bucket.

Firing

This could be the subject of a book in its own right, as the outcomes of clay mixtures and glazing depend so much upon it. However, briefly, a few thoughts:

1. Kiln size dictates object size, but not the size of the project. Small modules can make impressive pieces.

2. Ceramic fibre has made possible the creation of large kilns to fire one-off pieces. A steel frame can support the blanket through the use of clay buttons and stainless steel wire. Fuel can be wood, oil or bottled gas.

3. Loading the kiln may present some problems. Without a trolley hearth, it may be best to slide large heavy work into the kiln. I carry the work to the door on a strong board (with help) and prop it up or hold it in line with the kiln shelf. I coat the shelf with sand and if I can lift the piece, I place a piece of cardboard under it. If not, I slide the work partly off its board and place the card under the leading edge. The combination of card and sand enables the work to be slid fairly easily. Corrugated card also provides some cushion over uneven shelves and protects fragile corners of the unfired work. Left in place, it (except for a bit of residual ash) disappears in firing.

4. When firing, water is the major factor in most kiln disasters. And as more clay will contain more of this ingredient, it is essential to dry the work thoroughly. Even when dry, early stages of firing must proceed very slowly to avoid steam pressures within the piece.

5. Firing cycles will vary according to the work contained. For pieces which are grogged but fairly thick, say 2 inches (5 cm), an overnight warm to 100°C should be enough to dry work out. Then proceed gently to about 650°C, removing chemically-combined water. From this point, firing may be quite rapid to the desired temperature. In my gas-fired brick kiln, I count on 24 hours to reach temperature and 48 hours to cool down. If a fibre kiln is used, times tend to be faster, mainly due to a more rapid cooling of the kiln fabric.

Pip Warwick, who uses close grained slipcast bodies, will double the times given above. He pre-heats the kiln to 50°C before loading, and the initial warming to 100°C will be over a 24 hour period. The subsequent bisque firing to 1120° to 1150°C will take another 48 hours. He then glaze fires to 1080°C and adds lustres in another firing to 750°C.

Repairs

Every firing has the makings of a heaven and a hell. When results surpass expectations, it is delightful. When disaster strikes, gloom pervades the atmosphere. I've heard it said that you can tell the quality of the potter by the quality of the bits on the shard pile. The only thing is, what do you do when something goes wrong with one part of an overall plan? Do you repair it or wind up replacing the whole thing? And what happens if a small section of a large piece is damaged later? This happened to a column of mine when the painters dropped their ladder against it. To repair or replace will always be a personal decision. Yet it seems to me that there is more leeway in sculpture than in functional work and where the structural and aesthetic aims of a sculptural work are still being met, a repair is acceptable. A couple of possibilities:

1. Cracks may be filled by using ceramic materials such as stopping powders and kiln cements which may be fired and glazed. Rapid industrial developments are being made in this field and are advertised in current literature.

2. Resins, adhesives and rapid setting fillers which have been developed for automotive and other applications are strong, durable and may be coloured to match fired material.

Installation

Once the clay work has been completed, and the pleasure of a successful firing has subsided, there is still the substantial task of delivery and erection. Thoughtful attention to detail at this stage will determine not only the look of the finished article but how long it is likely to last.

Installation of the work is often one of the most difficult tasks to be undertaken. Scaffolding is often required and the practised skills of a mason are needed to assure straight courses, uniform joints and a minimal slopping of mortar down the surface of the brick. As a rule, I try to obtain a separate budget for installation, if only to highlight this area for the client. In some cases, the cost of installation will equal that of the commission itself,

'Andy Bennett memorial' by Jim Robison. Two-part sculpture is filled with concrete for durability. A threaded bar, anchored in the base, can be seen projecting from concrete.

Top portion of sculpture is bolted into place. Once filled with concrete, ceramic lids will cover access holes. A silicon sealer (Febsilcon) was brushed on completed work. Low planting will hide the concrete base.

although in new buildings, masons may already be employed and there will be no need to hire specialist assistance. Whether you or a builder/mason completes the installation, the following points are important:

1. Secure mounting is paramount. The last thing you want is for something to drop off a wall and damage something or someone. Exterior works need to be the most secure, due to the extremes of weather and possible physical abuse by vandals. Architects remain liable for injury or damage long after a building is completed and in my experience they insist on a 'belt and braces' approach to an installation of artwork.

2. External murals may need stainless steel fixings as well as the expected cement mortar. On new buildings, an engineering firm will probably request

information about weights involved and offer advice on load-bearing plinths and walls. It helps if you are prepared for this and provide the necessary mounting holes, grooves or notches.

3. Don't be too proud to ask for help. A good brick mason will cement a mural into place with a minimum of material and effort. And there will probably be less mortar to clean off of the surface afterwards.

4. Free-standing sculptures will need to be firmly anchored to solid foundations with rust-proof bolts or threaded bar. If in a public place, additional strength will be gained by filling the work with concrete.

Tile adhesives

Adhesives tend to be designed as much for the material that the tiles will be fixed to as for the tiles themselves. Examples of adhesives they might use:

To fix to any cement-based rendered finish, a cement-based mortar adhesive is recommended. Ardex, a German company manufacturer, provides two that are used extensively – X7G and X7W. Both are waterproof and may be used for pools or exterior walls.

Should there be a chance of movement within the structure (for example near a road or on a bridge), then an additive e.g. Ardion 90 can be used to give the adhesive long-term flexibility. This is also made by Ardex.

To fix to gypsum or plasterboard, BAL GRIP can be used.

To fix to fibreglass, glass or plastic, BAL FLEX can be used. BAL is a UK company based in Stoke-on-Trent.

All of these adhesives are available at tile suppliers and builders merchants.

Weather considerations

Even in secure, private gardens, anchorage is a must. I have lost more work to strong gusts of wind than vandalism. Frost damage is another major worry, but this can be limited with a few precautions.

1. Make sure there are adequate drainage holes in all work placed outside.

2. Point up relief sculptures and tiles with mastic or mortar so that water cannot get behind the work. If not pointed, be sure that water which gets in can run freely out again.

3. Design all work to avoid pools of water. Slope modelling so that rainwater runs off.

4. Water absorption can be a problem if the clay is porous. Soft bricks and stonework often get surface spalling as ice forms and expands beneath the surface. Silicon sealants, brush on liquids intended for porous walls, work equally well on sculptures and will provide long-lasting protection.

A further thought

When an architect or potential client questions the suitability of ceramic materials for outdoor sculpture, I often simply state that many buildings are made from bricks. So when considering large-scale work, it is worth remembering the strength of fired clay used as a building material. After all, the basic construction technique of stacking bricks has remained the same for thousands of years. When the builder stacks bricks on

top of each other, he is taking advantage of their great resistance to *compression*. He is never foolish enough to create structures that place the materials under *tension*; for any attempts to stretch clay will offer little resistance to cracking. Keeping this maxim in mind, however, the range of forms, colours and textures is nearly endless.

'Persian Carpet' swimming pool by Craig Bragdy Design Ltd. Applications such as this will require specific tile adhesives and firm foundations. Specialist advice is recommended.

Further reading

Books

Bitters, Stan, *Environmental Ceramics*, Van Nostrand, Reinhold. (A bit historic now, but stimulating, if you can find it in a nearby library.)

Casson, Michael, *The Craft of the Potter*, BBC Books.

Ceramic Review Book of Clay and Glazes, Craft Potters Association of Great Britain.

Daly, Greg, *Glazes and Glazing Techniques*, A & C Black; Kangaroo Press.

Dormer, Peter, *The New Ceramics*, Thames and Hudson.

Gibson, John, *Pottery Decoration*, A & C Black.

Gregory, Ian, *Sculptural Ceramics*, A & C Black.

Hamer, Frank and Janet, *The Potter's Dictionary of Materials and Techniques*, A & C Black; University of Pennsylvania Press; Craftsman House.

Hamilton, David, *Architectural Ceramics*, Thames and Hudson.

Rhodes, Daniel, *Clay and Glazes for the Potter*, A & C Black; Chilton Book Co.

Slivka, Rose, *Peter Voulkos*, New York Graphic Society (published by Little, Brown).

Speight, Charlotte, *Images in Clay Sculpture*, Harper & Row.

The Trojan War (sculptures by Anthony Clare), Lund Humphries.

Periodicals

Artists Newsletter, monthly, AN Publications, PO Box 23, Sunderland SR1 1BR, UK.

Ceramic Review, Bi-monthly, available from 21 Carnaby Street, London W1V 1PH, UK.

Ceramics Monthly, Available from 1609 Northwest Blvd., Box 12448 Columbus, Ohio, 43212, USA.

Ceramics: Art and Perception, Quarterly available from 35 William Street, Paddington, NSW 2021, Australia.

Studio Potter, Bi-annual, Box 70, Goffstown, N.H. 03045, USA.

Studio Pottery, Bi-monthly, available from Studio Pottery, 15 Magdalen Road, Exeter, Devon EX2 4TA, UK.

Index

Note: numbers in italics denote pages with illustrations